CUT &
PASTE

21ST CENTURY COLLAGE

LAURENCE KING

Published in 2011 by
Laurence King Publishing Ltd
361–373 City Road
London EC1V 1LR
United Kingdom
Tel: + 44 20 7841 6900
Fax: + 44 20 7841 6910
e-mail: enquiries@laurenceking.com
www.laurenceking.com

Reprinted 2011

Book concept, artist selection and
picture research by Richard Brereton
Copyright © text 2011 Richard Brereton
and Caroline Roberts

A catalogue record for this book is available
from the British Library

ISBN: 978-1-85669-717-0

Designed by Masumi Briozzo

Cover image © Serge Bloch
Cover design by Masumi Briozzo

Project Editor: Gaynor Sermon
Copy Editor: Angela Koo

Printed in China

CUT &
PASTE

21ST CENTURY COLLAGE

Richard Brereton
with Caroline Roberts

LEARNING
RESOURCES
CENTRE

Laurence King Publishing

FOREWORD

In a digital age where a lot of images created on a computer tend to look like just that, many creatives are increasingly using more traditional methods to visually interpret our ever-changing world.

In the movie *Blade Runner*, the future constantly referenced the past. Evidently we are nostalgic for what was, we are reassured by the familiar. Collage is a medium that connects the past with the present, sometimes offering a glimpse of what may be the future.

From fashion show invitations to the backdrops of music videos, from graphic design to book illustration, contemporary collage has become a significant part of our visual landscape. The fusion of disparate and juxtaposed assemblage images provokes questions, ambiguous questions that we may not be able to answer.

In compiling this book I have aimed to include a representative selection of the many very different and talented artists who currently work in this medium. This is not necessarily a definitive list, but is a cross section depicting the breadth of today's collage art.

Richard Brereton

CONTENTS

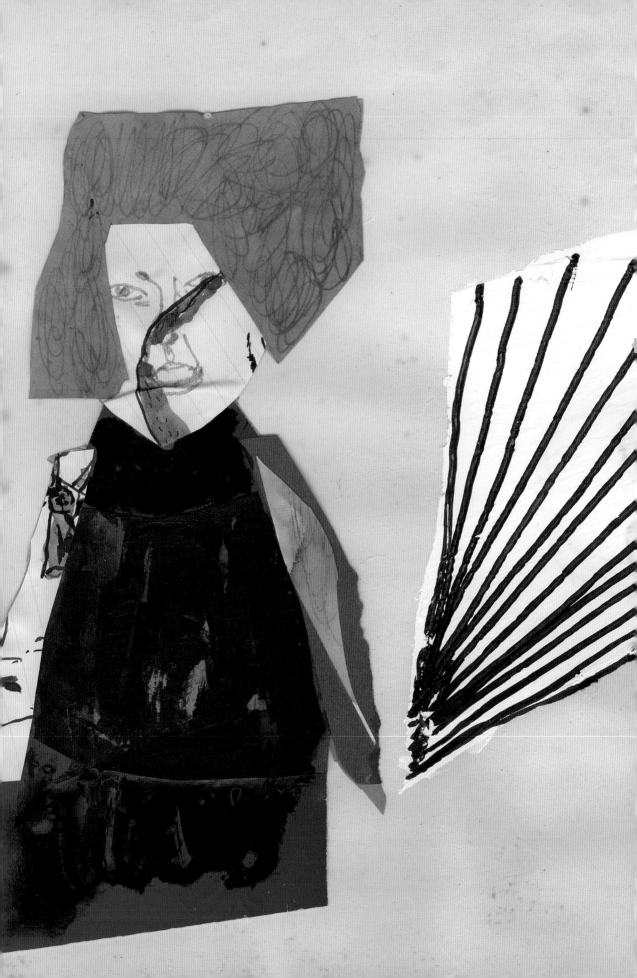

1

CRAIG ATKINSON

Craig Atkinson's love of spontaneity
means that collage is the perfect medium
for his work – he treats each piece as a
journey, never quite knowing where it
will end up, but clearly enjoying the ride.
His approach is strictly analogue: 'I like
doing things you're told not to do. So
smudging pencil marks, sticking things
to the surface of a painting, and hanging
work on paper by a nail are things I do
quite often.' He uses his own work to
create 'collages of collages', and anything
that he's not happy with is reused in a
future piece. This has led to some truly
unexpected compositions, and a series of
striking little collaged figures which are
the embodiment of his random approach:
'I collect heads and put them in bags,'
he explains, 'then I do a "lucky dip".'

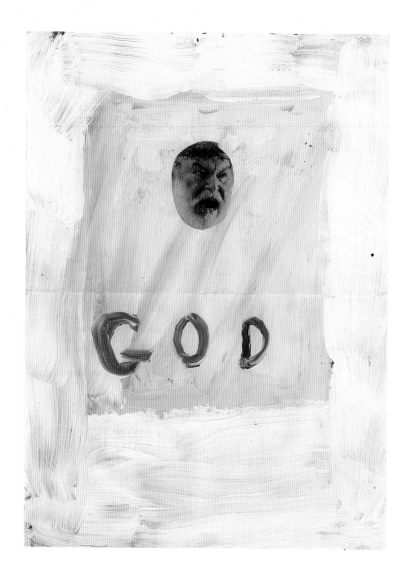

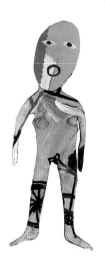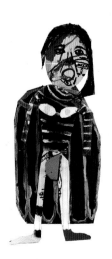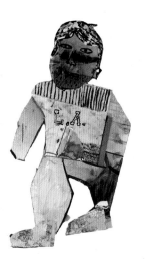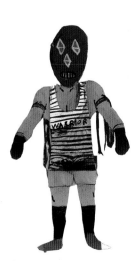

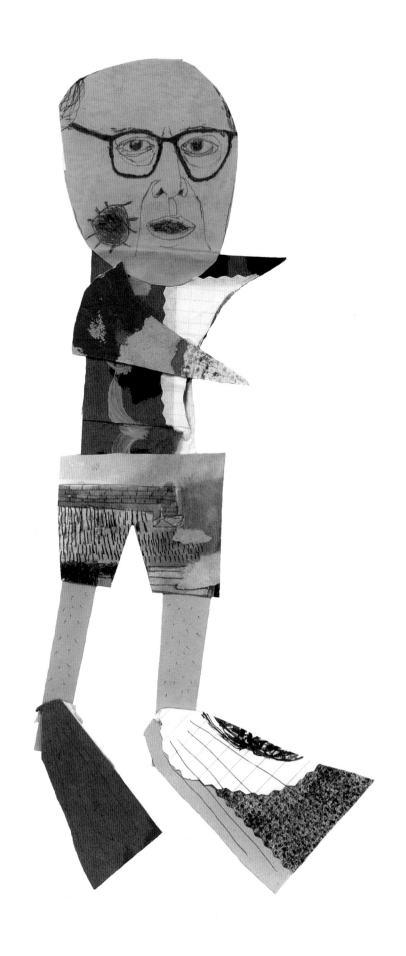

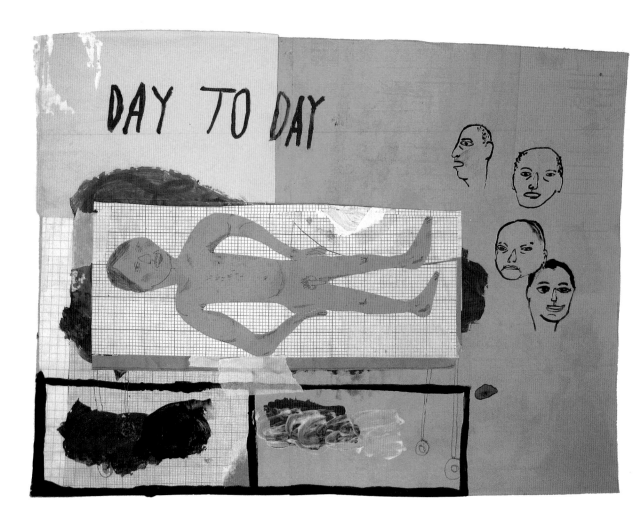

Above
Day to Day, mixed
media, 2008

Opposite
Limon, mixed
media, 2007

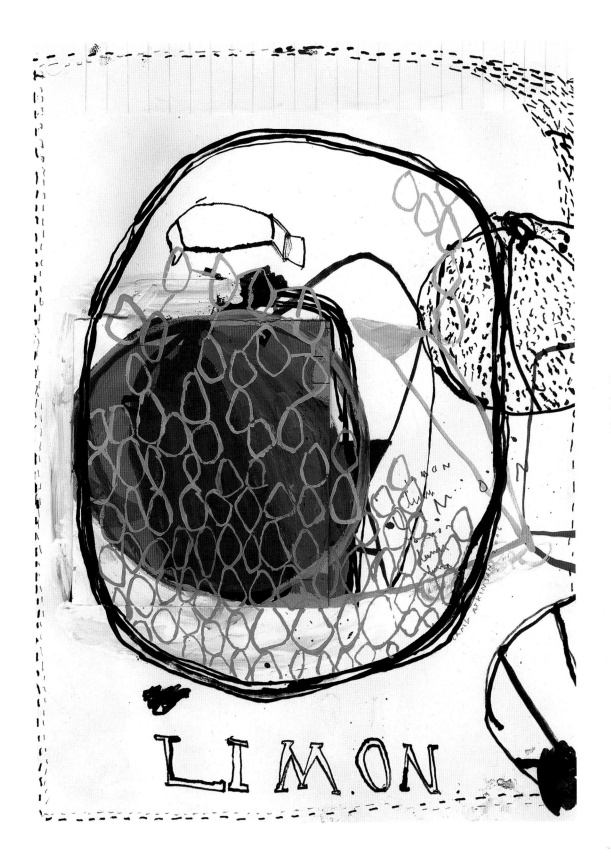

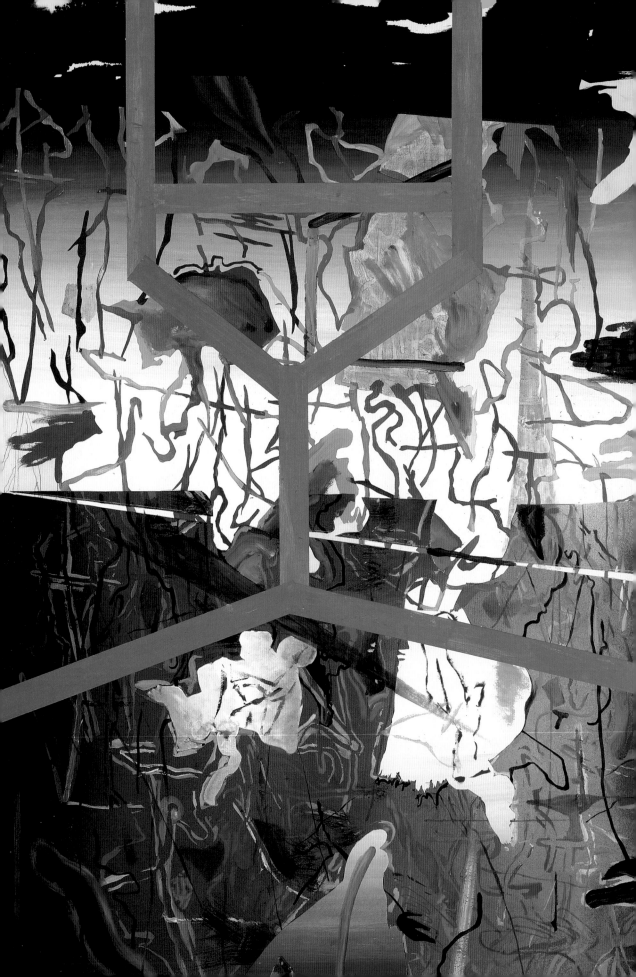

2

DREW BECKMEYER

There is always an element of collage
in LA-based artist Drew Beckmeyer's
work – sometimes it's a tiny part, other
times the entire piece will be formed of
collage. Beckmeyer's beautifully dense
pieces form complex landscapes, which
are becoming 'a lot more crowded, with
less white space, less clarity of imagery
and narrative point'. He uses his own
work as the basis for his collages, and
has been careful to retain his diverse
and experimental approach to media and
composition. This and his preoccupation
with the darker side of beauty are what
make his work so intriguing. By his own
admission, his work is always in a state
of flux: 'I am starting to accept that, for
better or worse, I'm not one to linger on
a single idea for too long.'

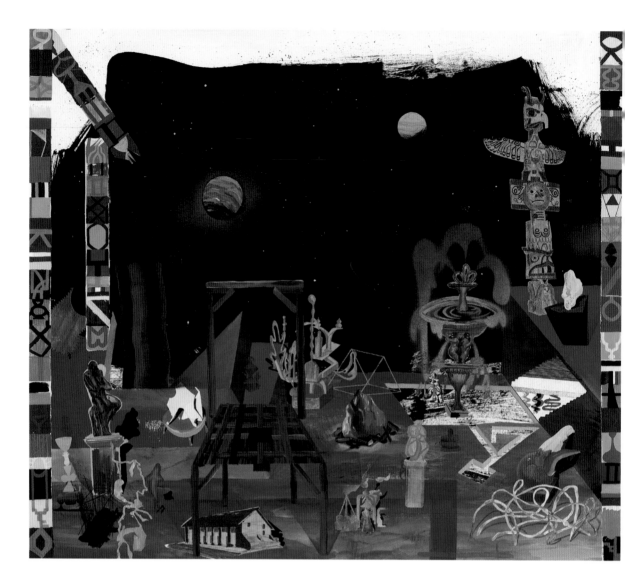

Previous page
*Scared of Death, but
Looking Forward to
the Flying*, oil, acrylic,
ink, cut paper on
paper, 2008

Above
*Church, Courthouse,
Saloon, and Sculpture
Garden were Sometimes
One and the Same*, ink,
gouache, acrylic, cut
paper on paper, 2008

Opposite (top)
Devil's Post-Party,
acrylic, pastel, spray
paint, cut paper on
paper, 2008

**Opposite
(bottom)**
*Coming to Terms with
Germany*, oil, ink,
spray paint, cut paper
on paper, 2009

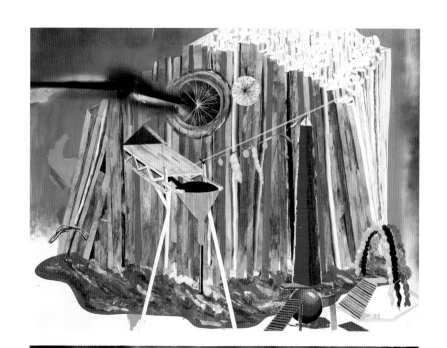

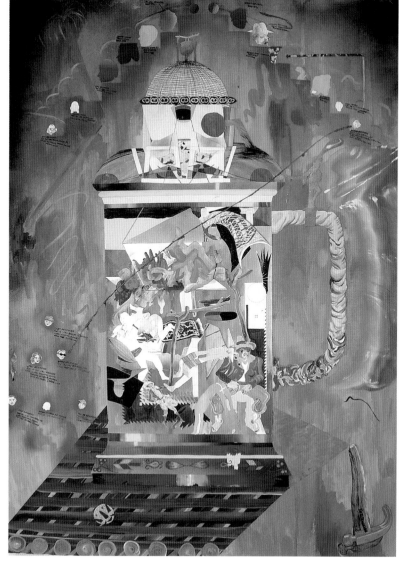

SERGE BLOCH

Serge Bloch is an author and illustrator whose humorous collages mix drawings and found imagery. Based in Paris, his work has been published and exhibited around the world. To Bloch, collage is 'adding an element that is dense and pictorial to whatever my means of expression is', explaining that it is the combination of two moments – that of collecting the source imagery and then of the spontaneous drawing – that makes his work interesting and unique: 'The little ticket becomes the mouth of the character, which seems to be waiting for its turn to speak; the old light socket becomes a dog's head; a passport photograph is attached to a newly imagined body.' His roughly hewn sketches are designed to capture a spirit of fun, precisely by not being overworked, and his method of adding to the drawings gives them a new dimension, causing the viewer to smile at the juxtaposition of imagery.

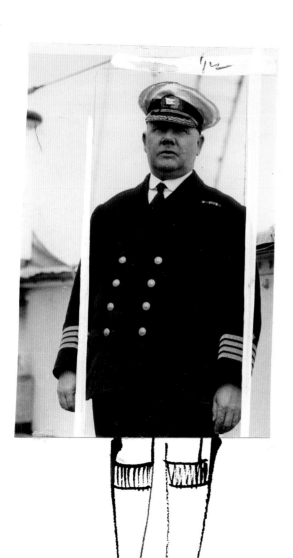

Previous page
Open, photography
and ink, 2009

Left
Mermaid, for Living
with Art gallery, New
York. Ink and collage
on paper, 2009

Below
Phone Doodle #3,
mixed media, 2007

Opposite
Introuvable, ink on
old paper, 2009

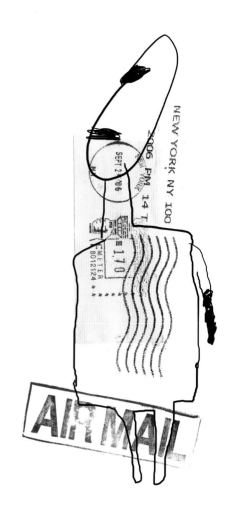

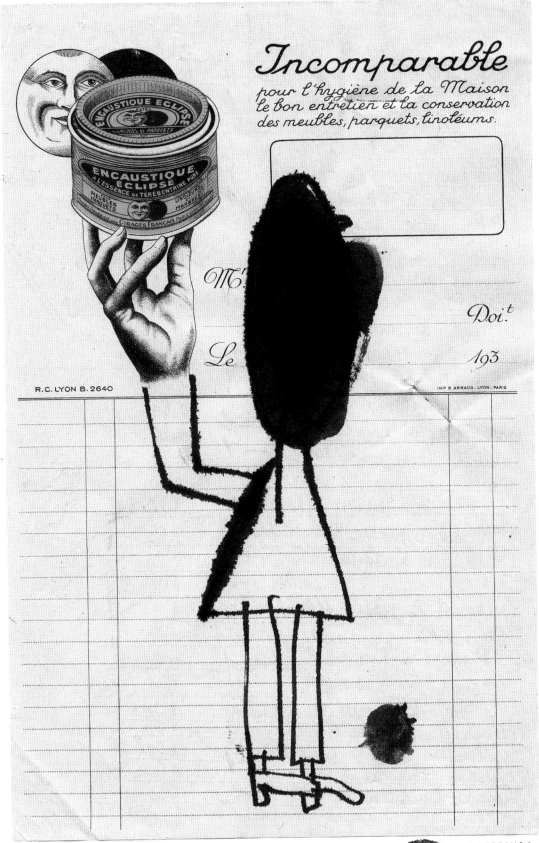

Right
Not Kosher, Paris,
mixed media, 2005

Opposite (top)
NYC, pencil on
stamped envelope,
mixed media, 2008

**Opposite
(bottom left)**
Mutants, for the
New York Times
science section,
mixed media, 2007

**Opposite
(bottom right)**
Condom, photography
and Photoshop, 2008

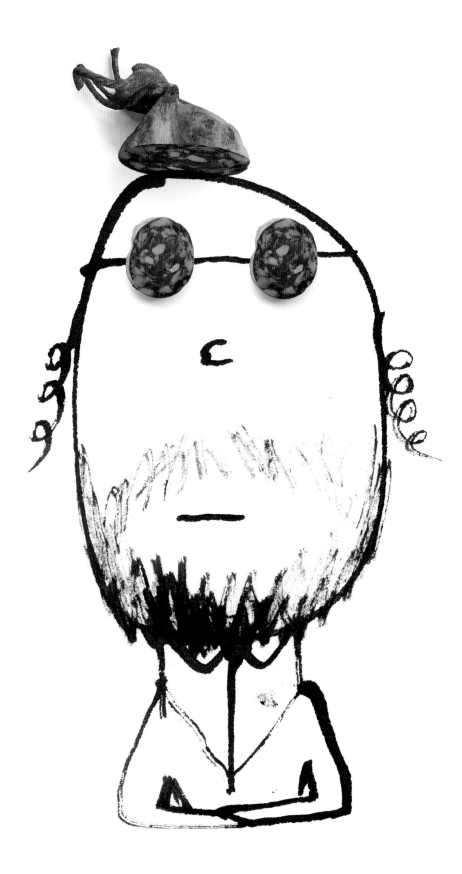

SEP 19 2006

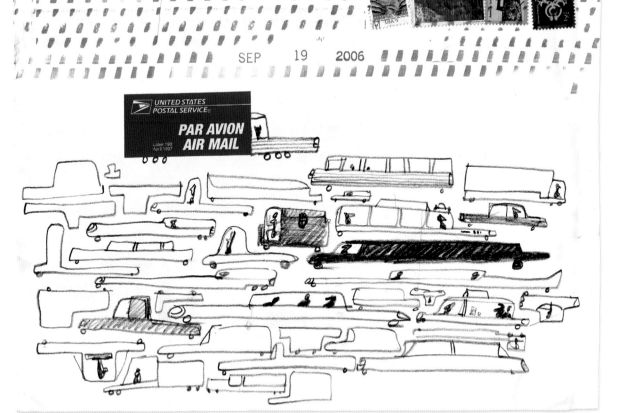

UNITED STATES POSTAL SERVICE®

PAR AVION
AIR MAIL

Label 19B
April 1997

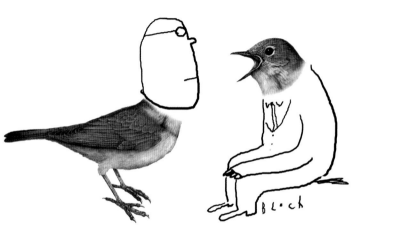

Bloch

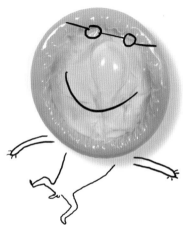

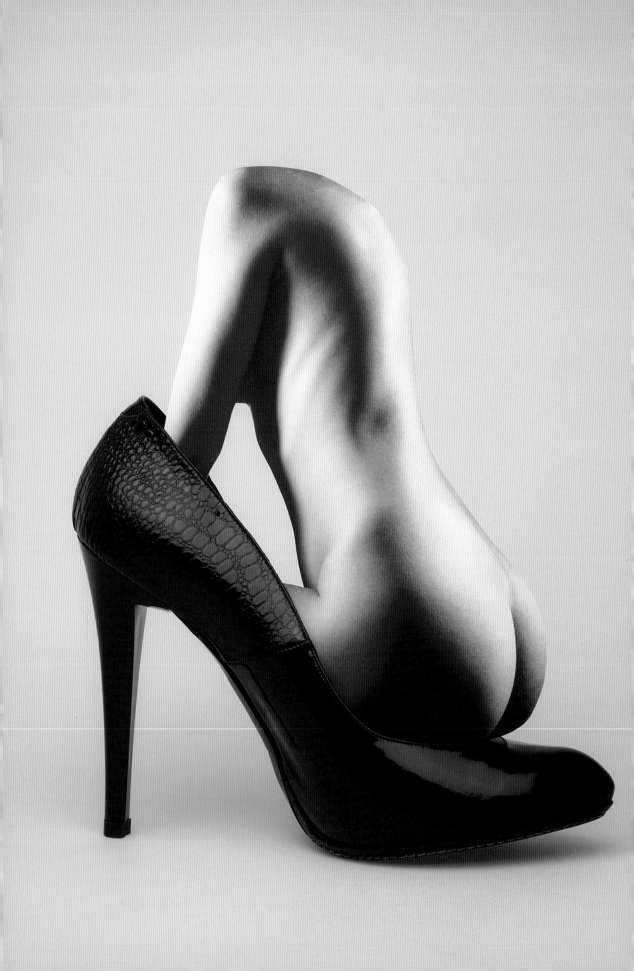

BELA BORSODI

Describing his production method as 'fearless trial and error', New York-based still life photographer Bela Borsodi's seductive work features fashion and fetishism in equal measures. Collage has always played a big part in his creative process, as a way to both develop his ideas and communicate these to his clients. He likens using collage to the way an artist uses a brush – as a tool rather than a medium – and deliberately chooses source material which is not that exciting in itself. While he rarely uses digital manipulation in his photography, his approach to collage is very different: 'I have to force the source material to come together. I reshape it, change its colours and morph it to extremes. I combine images and turn them around... for me it's just material to work with, never something that can just function as it is.'

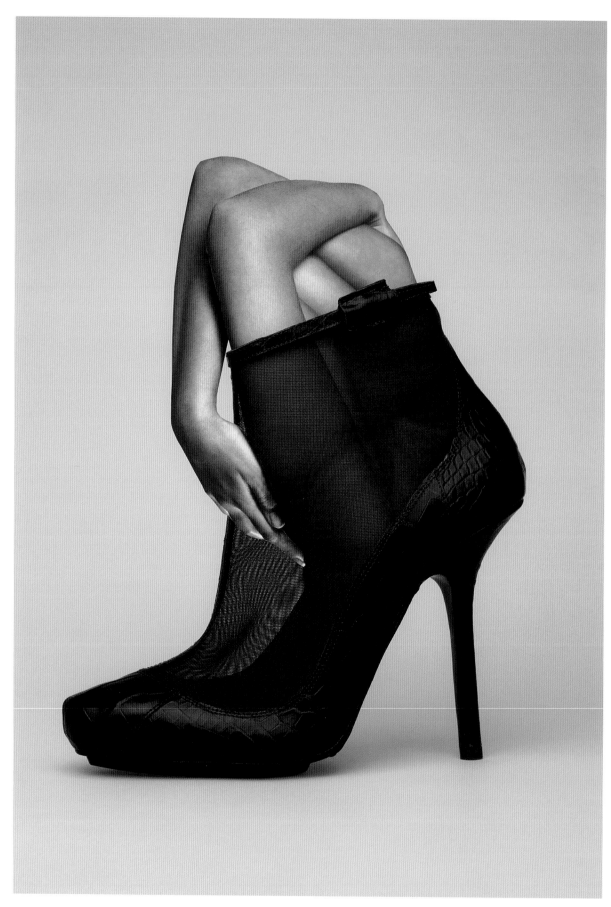

All images
Foot Fetish,
photographed for
V Magazine, 2007

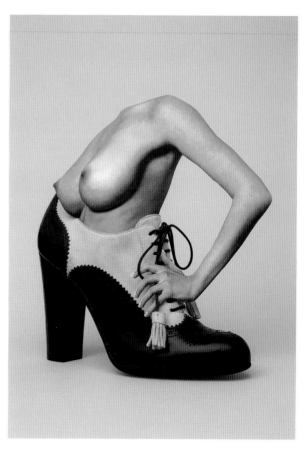

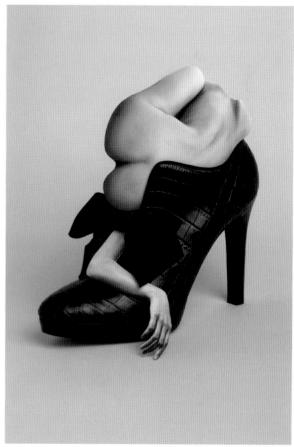

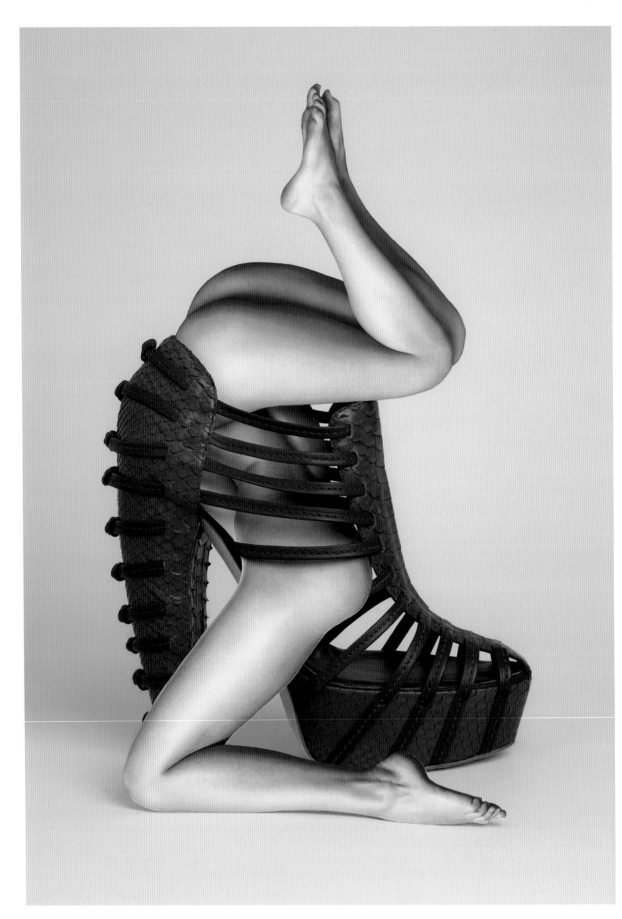

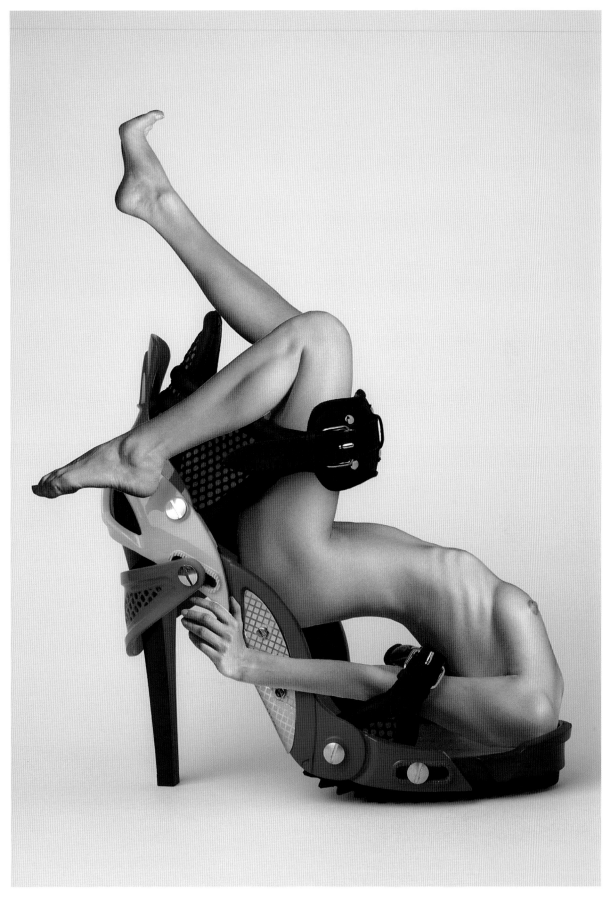

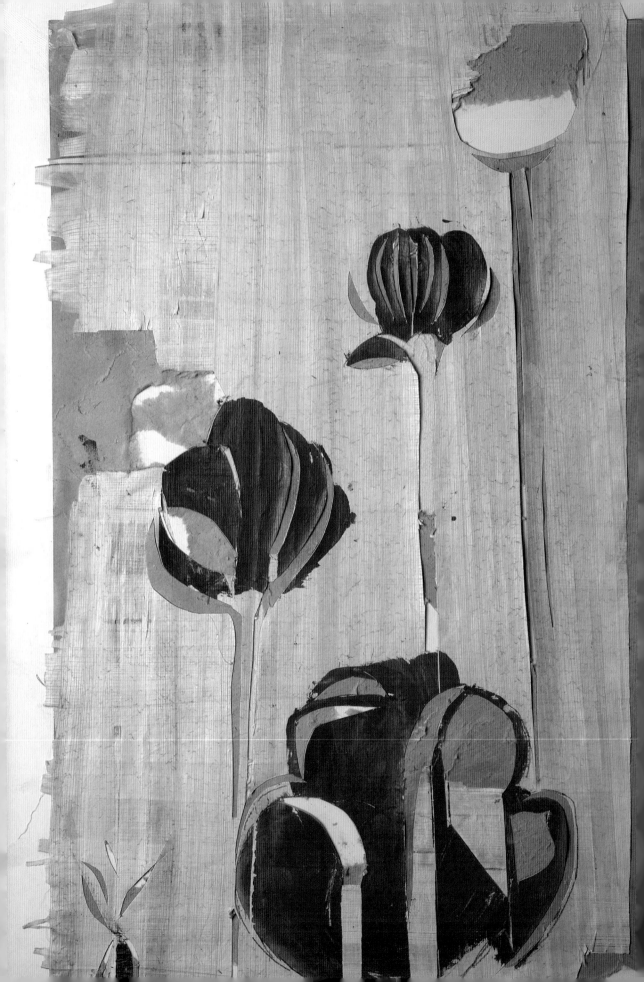

5

SAM CHAMBERLAIN

Sam Chamberlain's nature-inspired, multilayered work uses torn paper and paint to reveal subtle influences from a period of five years spent travelling in India as a child. Born in New York and now based in London, he is one of the few artists to acknowledge the importance of glue in the cut-and-paste process: 'Gluing layers of paper onto one another and then cutting through them produces interesting, sometimes unpredictable effects, and gives an unclear view of depth, foreground and background. I think the glue itself is also an element in my work.' Chamberlain paints marks onto the layers of glued paper and then uses a knife to strip away and reveal certain elements, describing the process as 'a sort of reductive collage, or de-collage, if there is such a term'.

Previous page
*Poppy Race (for
a Dutch Tulip)*,
acrylic and papyrus
collage, 2009

Right
Flowers for Gaza,
acrylic and papyrus
collage, 2009

Below
Green Landscape,
acrylic and papyrus
collage, 2009

Opposite
Fall, Fowl, Lizards,
acrylic and papyrus
collage, 2009

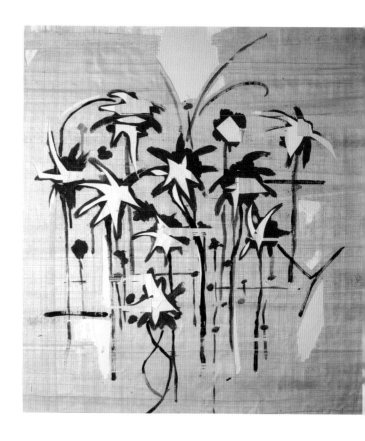

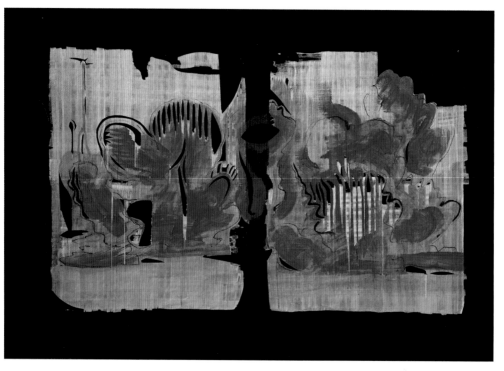

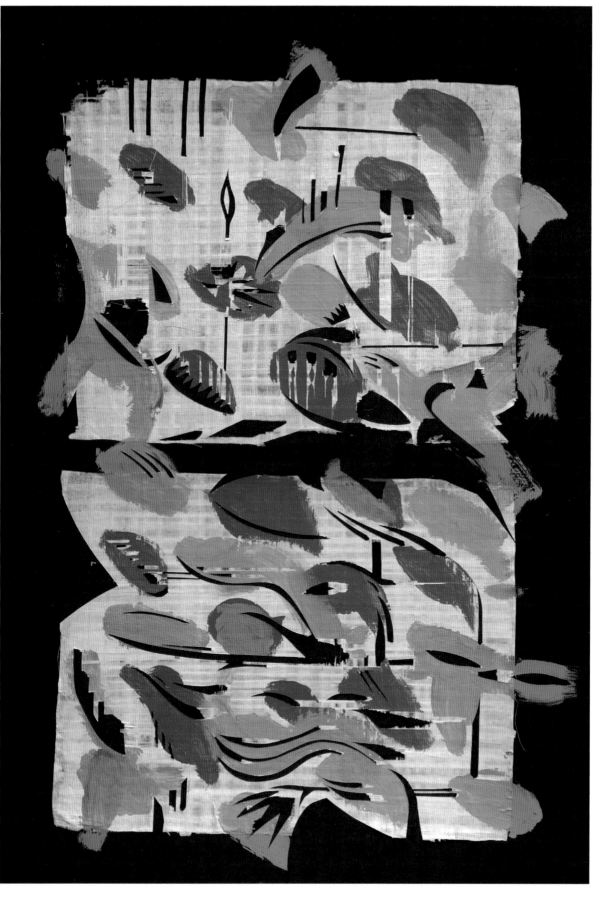

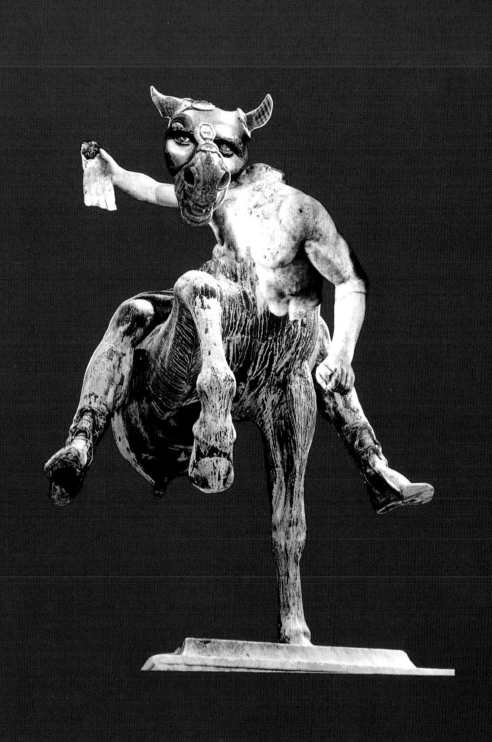

JOÃO COLAGEM

Brazilian-born, Rotterdam-based artist João Colagem can pinpoint exactly when the collage bug first hit – it was at school when he was five years old and he glued a cut-out image onto an empty mayonnaise jar. Collage is an important cultural tradition in Brazil: 'We learn it in primary school and it stays glued in our lives. It happens this way because of basic necessity. There are no coloured pencils, paints or other materials to express yourself. So glue it!' He mixes images from sources such as *Playboy*, *Homes and Gardens* and *Veja* magazines with those from books on classical art to powerful effect, and continues to have a passionate relationship with the process: 'I don't cut, I breathe and devour paper archives, diverse collections of art books and magazines; as my great friend Peter Zwaal says, I don't cut, I am a butcher and hack them, and afterwards take them to the work table and I am fulfilled.'

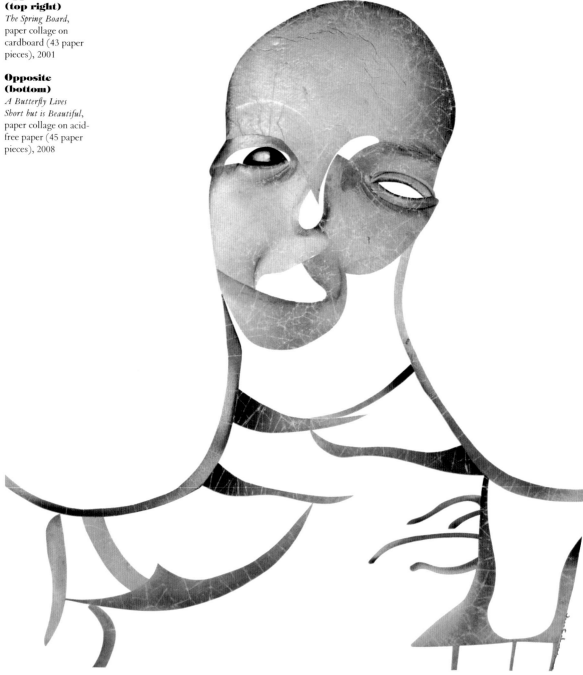

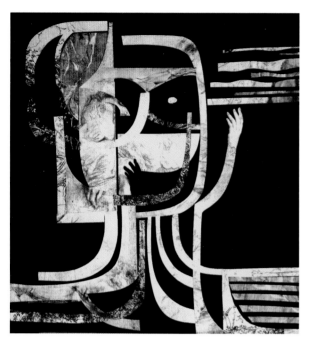

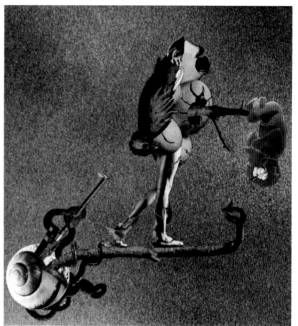

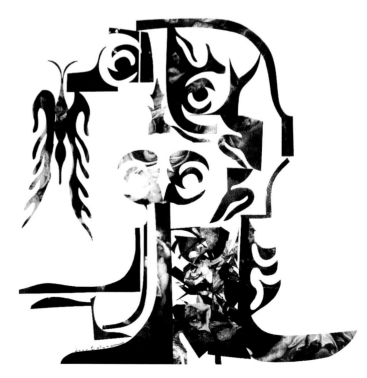

Right
The Truth has no Value, paper collage on acid-free paper on MDF (33 paper pieces), 2007

Below
Skin and Wires, paper collage on acid-free paper (14 paper pieces), 2007

Opposite (top left)
The Head of an Idiot, paper collage on MDF (14 paper pieces), 2004 (inspired by the Rotterdam painter Dolf Henkes, 1903–1989)

Opposite (top right)
The Dialog, paper collage on MDF (10 paper pieces), 2004

Opposite (bottom)
Skin and Wires, paper collage and cord on acid-free paper (14 paper pieces), 2007

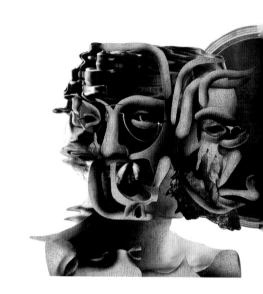

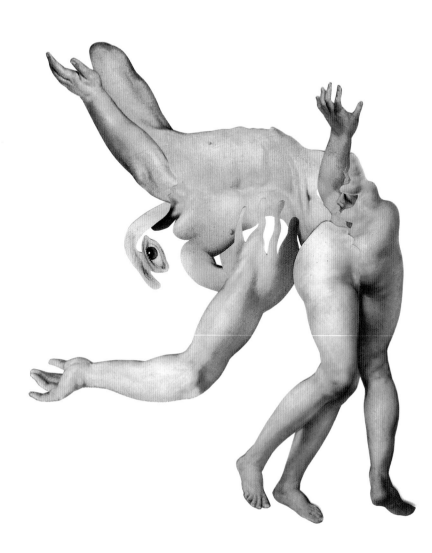

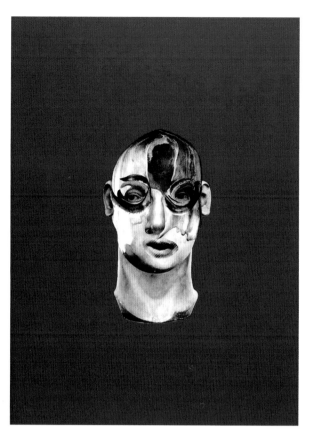

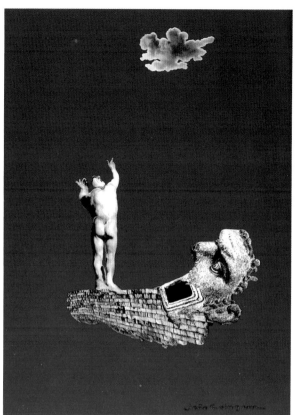

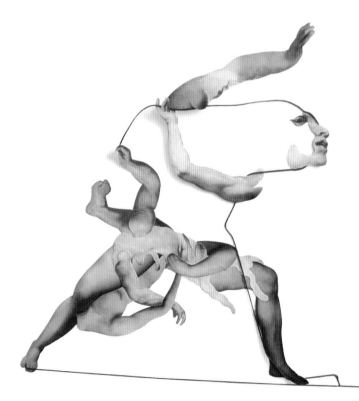

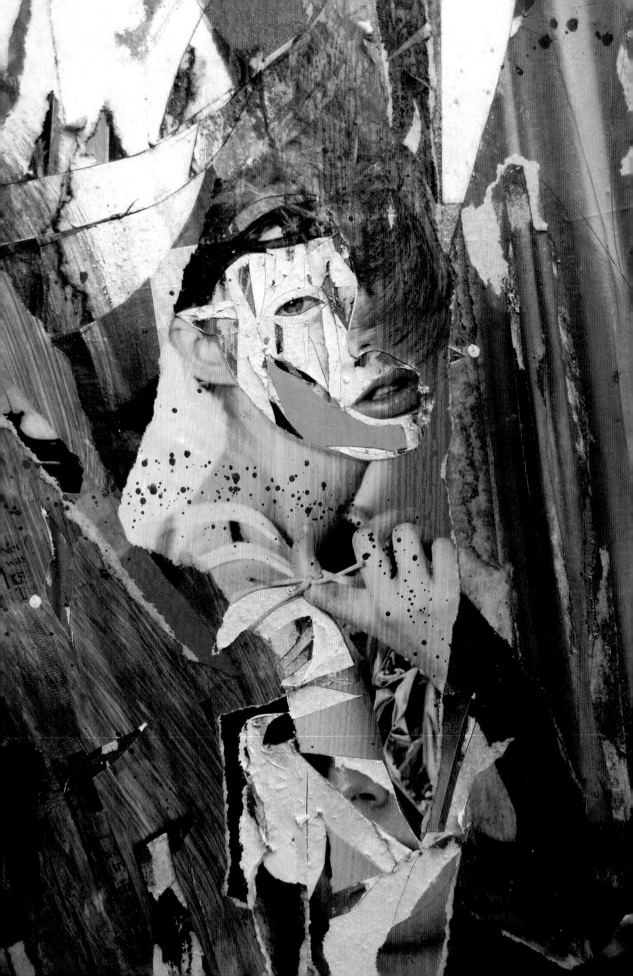

7

ALEX DAW

Alex Daw's work possesses an edginess that has seen him show at galleries including the National Portrait Gallery, and take commissions from famous fashion houses such as Ralph Lauren. Combining painting and collage, Daw uses imagery taken from magazines as diverse as *National Geographic* and *Penthouse* and gathered media from the flea markets of Berlin. Describing the images that he is drawn to as 'sexual, sophisticated, sci-fi and natural history', he talks about collaged images having a 'glossy, finished quality'. He is constantly looking for ways to combine painting and collage in new and arresting ways. Although the source material is always commercial printed matter, there is a raw quality to his creative process: 'There's definitely something of the outsider in me, just rifling through random sources and ripping and sticking things together, it's quite carnal.'

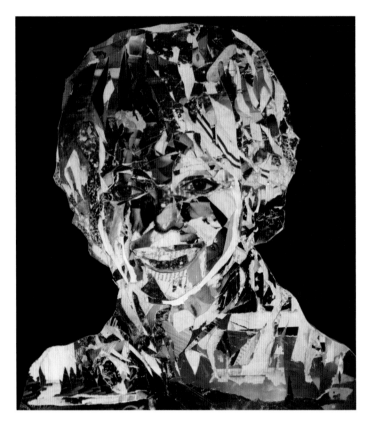

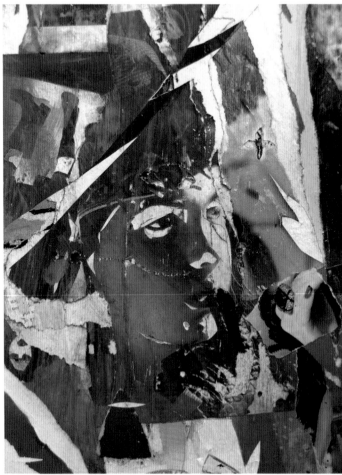

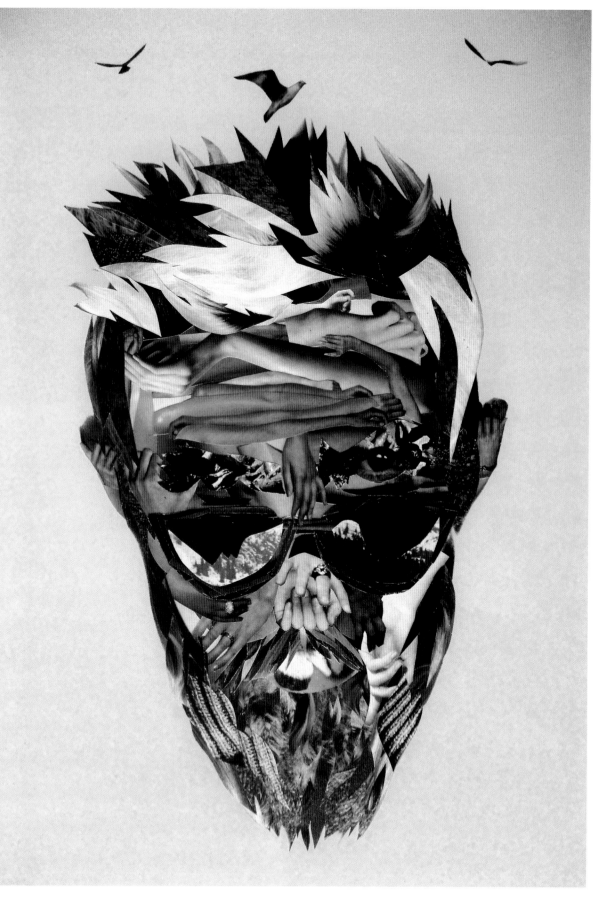

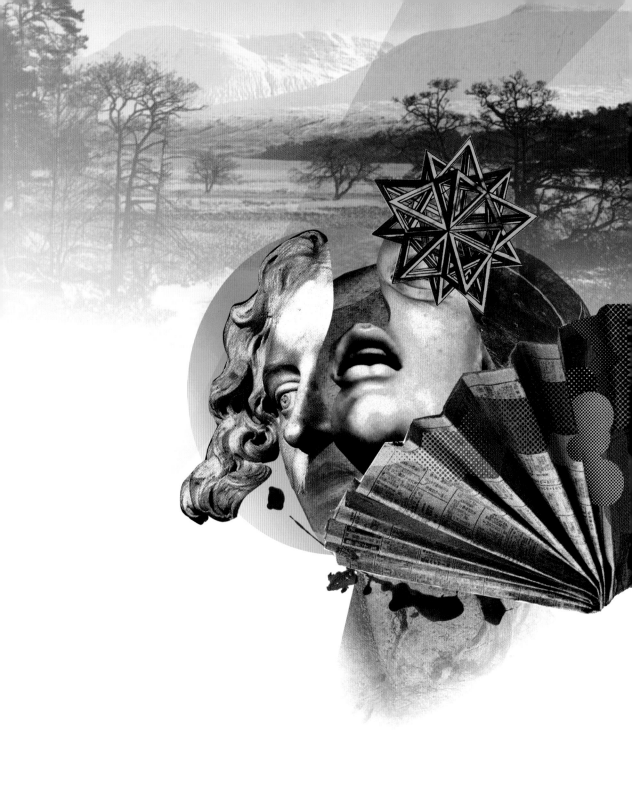

8

JAMES DAWE

East London-based James Dawe's 'subversive and surreal' photomontages feature many seemingly unrelated images that appear to fit perfectly together, juxtaposing weird and wonderful elements that somehow seem to make sense. Working digitally using many of his own photographs and drawings, he loves the fact that 'with a collage you can create a heightened and twisted reality' which becomes so much more believable when a photographic image is used. Dawe's work has a real element of surprise and although his pieces are meticulously composed, viewers sometimes remark that they look like they've randomly fallen into place. He also enjoys the restrictive element of working with found imagery: 'Collage also offers restrictions, as you have to make do with the imagery you find, can get your hands on – this is part of the beauty of it – the selectiveness.'

Previous page
Gasping Bust, for
Fabric Nightclub
(art direction by
Village Green),
digital photo-
collage, 2007

Right
Art Torso, for SMU
Meadows School
of the Arts, Dallas
(design agency
Matchbox Studio),
digital photo-
collage, 2008

Below
*Financial Times
Worldscape*, for the
FT (ad agency DDB,
London), digital
photo-collage, 2007

Opposite
Easter Creatures, for
Cadbury's Exhibition
(ad agency Publicis),
analogue and digital
collage, 2008

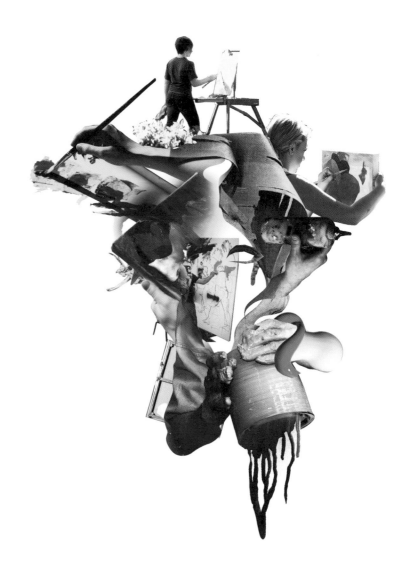

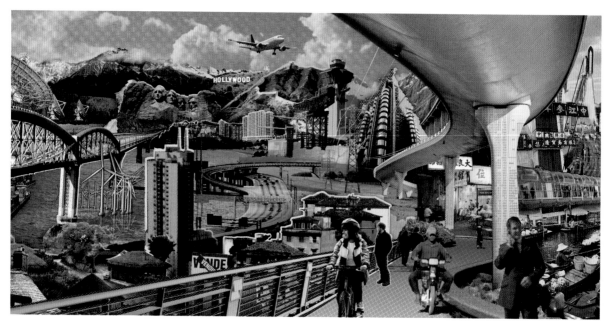

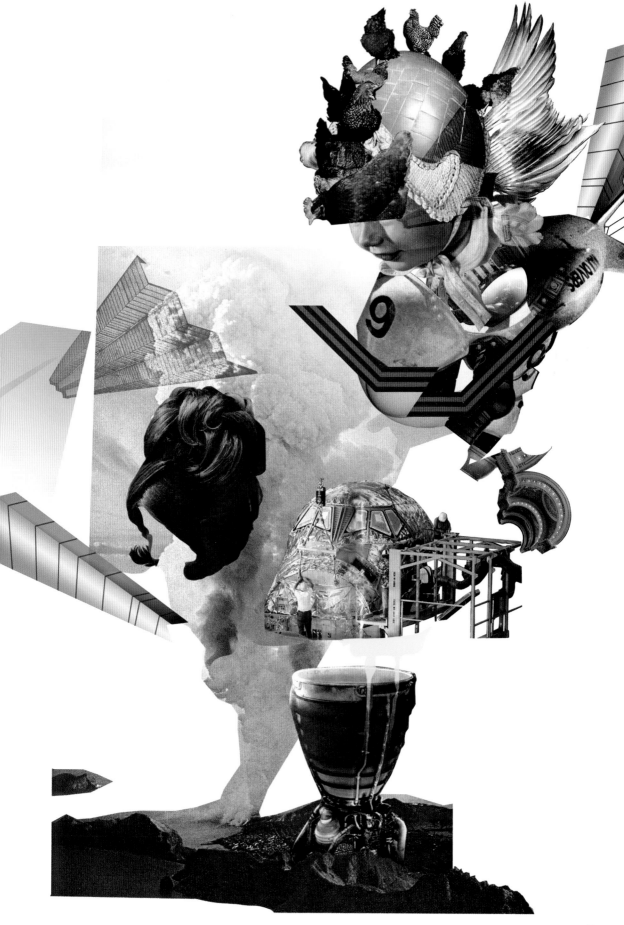

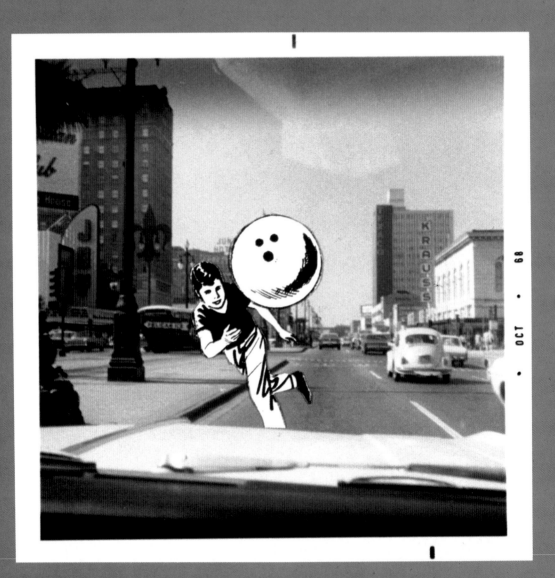

9

ANDY DUCETT

There's a nostalgic, almost retro feel to many of Andy DuCett's gentle collages, which are created from cuttings from newspapers and magazines from the fifties and sixties, receipts, cast-offs, clip art annuals, maps and photographs. His downtown location has continually provided him with a rich source of material: 'My studio is on a back alley in south Minneapolis, perfect for dumpster diving.' DuCett often combines just two elements in his work, both of which are still completely recognizable, enjoying how 'two or more materials can come together and make new meaning without necessarily erasing their original intent.' In an increasingly digital world he's convinced that analogue methods will still be very relevant: 'There will be a greater need for the tactile and tangible. I'm not a Luddite by any stretch, I'm just hopelessly nostalgic.'

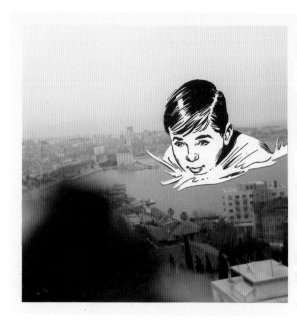

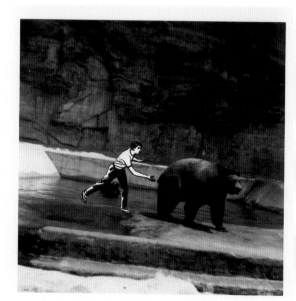

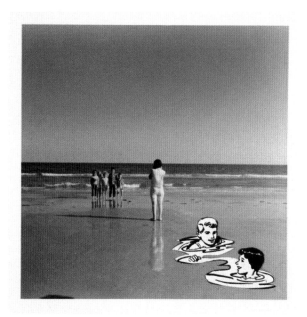
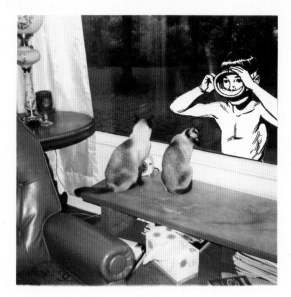
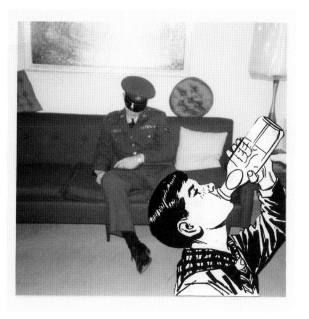
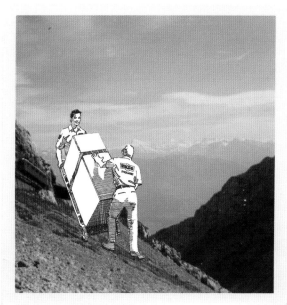

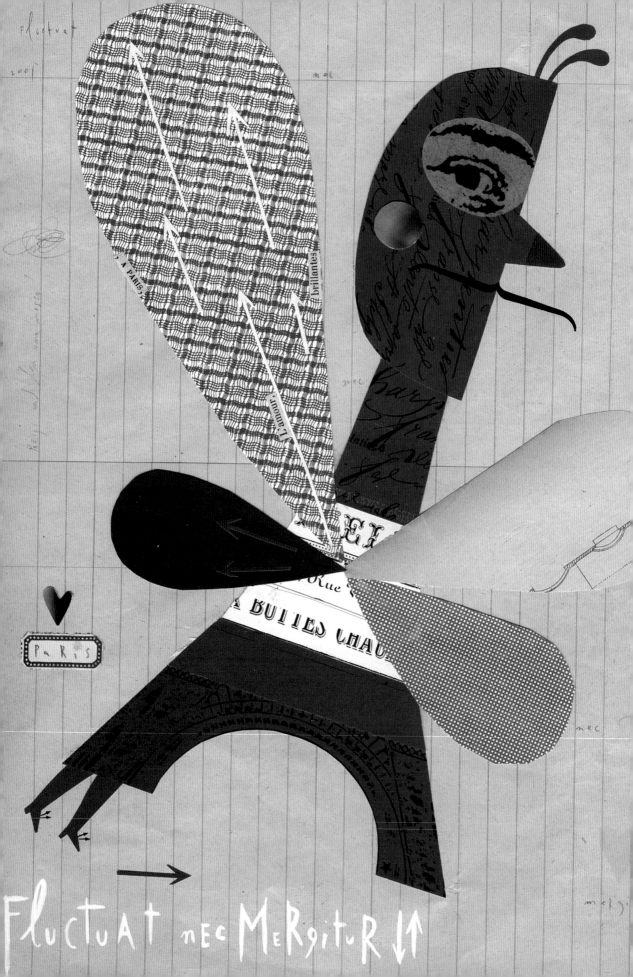

10

SARA FANELLI

Sara Fanelli's sophisticated style of collaged and drawing-based illustration is instantly recognizable. The London-based illustrator's work has appeared in numerous books and magazines, and she has won many awards and accolades. Her finely crafted mix of collage and drawing has a playful (and occasionally slightly menacing) quality which appeals to old and young alike. As well as being commissioned by an impressive list of clients, she has created many of her own children's books, which have been published in several different languages. Fanelli's love of aged papers, with their surface marks and imperfections, gives her work warmth and texture. She never uses digital imagery as a reference: 'For me it is vital to play with and celebrate the actual tactile qualities and textures of the real paper.'

Previous page
AGI Paris poster,
collage, 2001

Right
*Pinocchio (At the
Circus)*, Walker
Books, collage, 2004

Below
*Pinocchio (The Puppets'
Theatre)*, Walker
Books, collage, 2004

Opposite
Pizza Express
menu, collage and
gouache, 2005

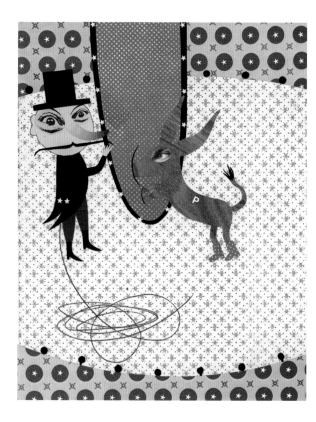

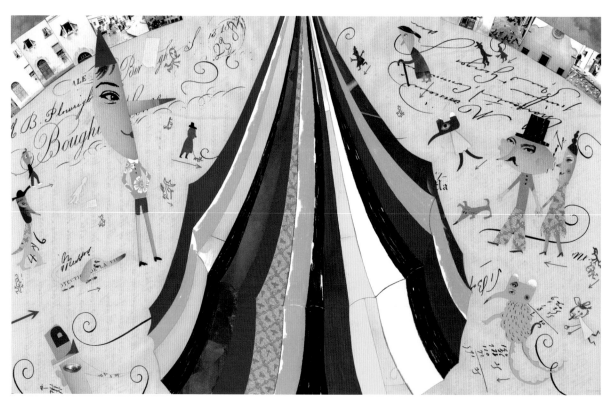

MINIMALISM is UNDERRATED. LESS IS MORE, THAT is MY motto. TAKE tHE Margherita: NO FUSS, NO BOTHER. JUST pure, simple FLAVOURS. WHAT A WORK of ART.

MARGHERITA

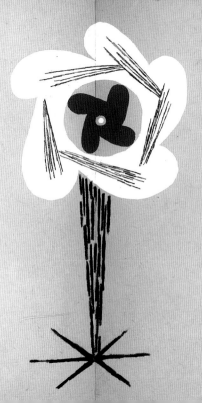

55

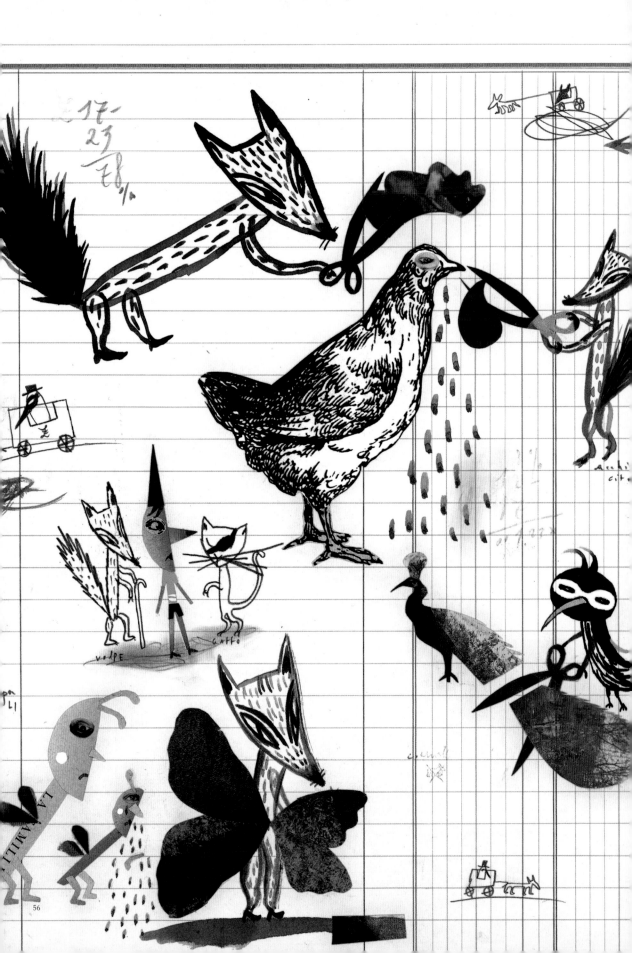

Left
*Pinocchio
(Swindletown)*, Walker
Books, collage, 2004

Below
*Pinocchio (The Cat
and the Fox)*, Walker
Books, collage, 2004

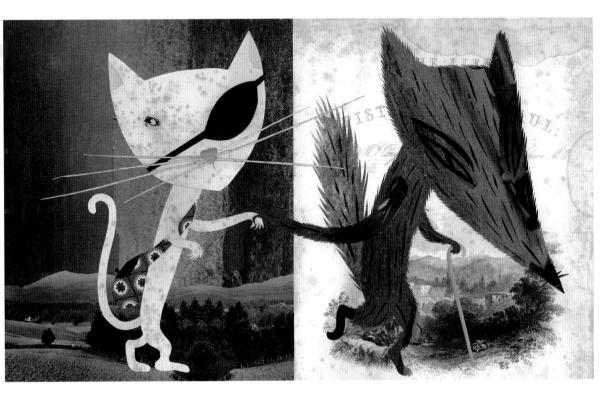

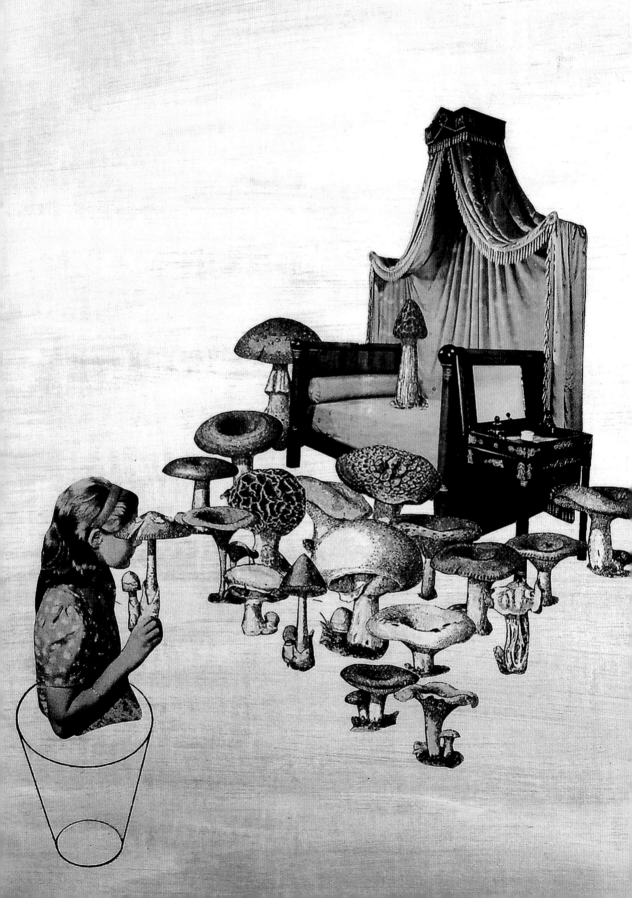

11

EVA EUN-SIL HAN

The subconscious is a subject that is at the heart of Korean-born Eva Eun-Sil Han's intriguing collages. Now residing in Belgium, she was inspired to start using the method of cut and paste when she discovered the work of Max Ernst, a pioneer of the Surrealist and Dada movements and one of the original Abstract Expressionists. Using images culled from 1950s *National Geographic* magazines and vintage photos from the nineteenth and early twentieth centuries, she creates mysterious tableaux that demand closer investigation. Her work is 'all about the subconscious. It is used in many different contexts and has no single or precise definition.' This is at the heart of her intriguing collages; the subject of psychology fascinates her. She cites Sigmund Freud as a big inspiration, particularly his observation that, 'The only trustworthy antithesis is between conscious and unconscious.'

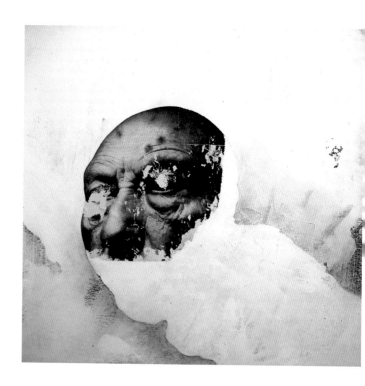

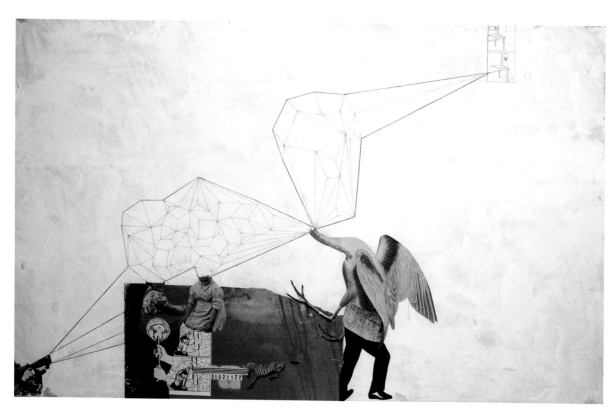

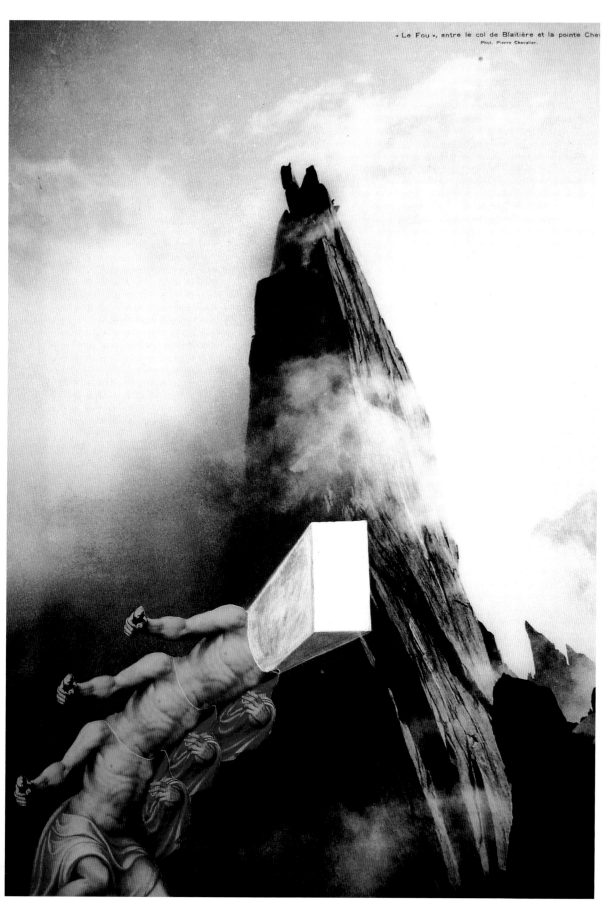

« Le Fou », entre le col de Blaitière et la pointe Chev
Phot. Pierre Chevalier.

61

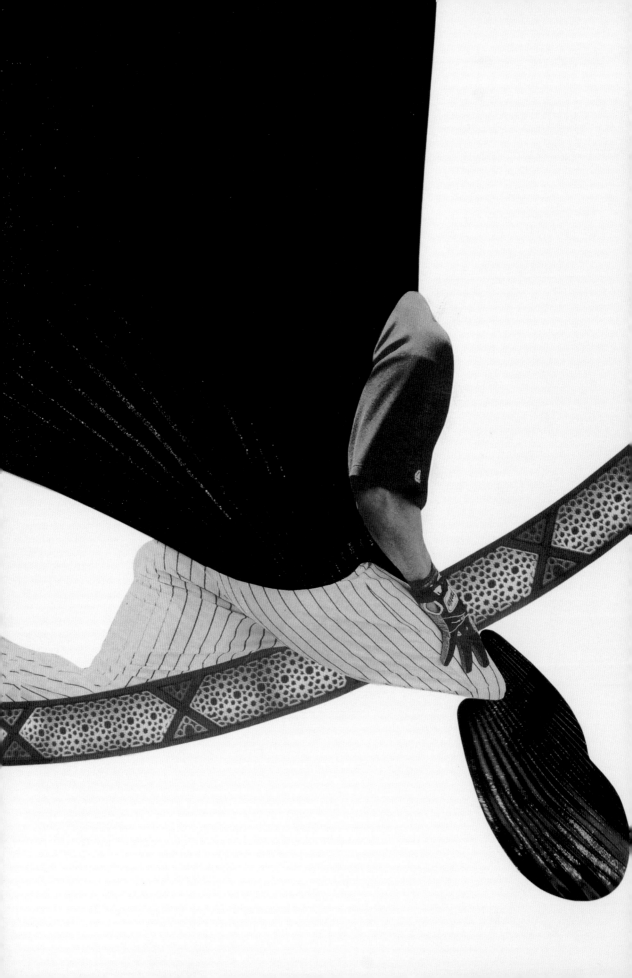

12

QUISQUEYA HENRIQUEZ

Quisqueya Henriquez divides her time between the Dominican Republic and Miami, enjoying the freedom of working between two different cultures. Her striking, graphic collages often use newspaper imagery. Taken out of context these help to make powerful new visual statements: 'One image seen by thousands of people transforms itself, acquiring other meanings, other destinies.' Many people who saw her series featuring baseball players didn't even realize that collage was the process used, because it was difficult to decipher between the cut-out image and the paper below. Henriquez relishes the process of selecting and collecting images: 'In a piece of paper otherwise seeming insignificant, you could find the fundamental component for a work of art. The waiting plays a determining role – waiting for a decisive fragment to emerge.'

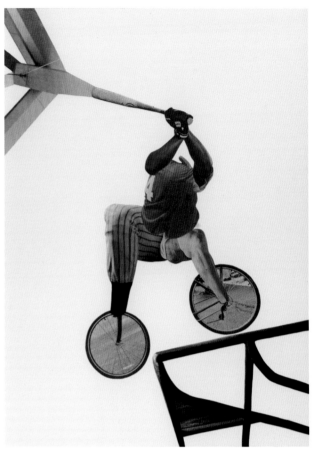

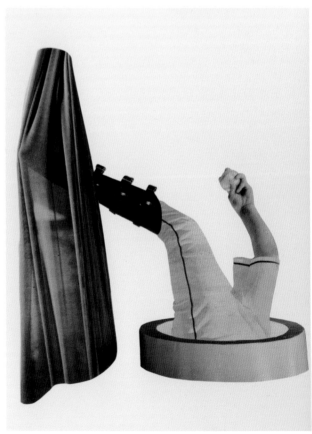

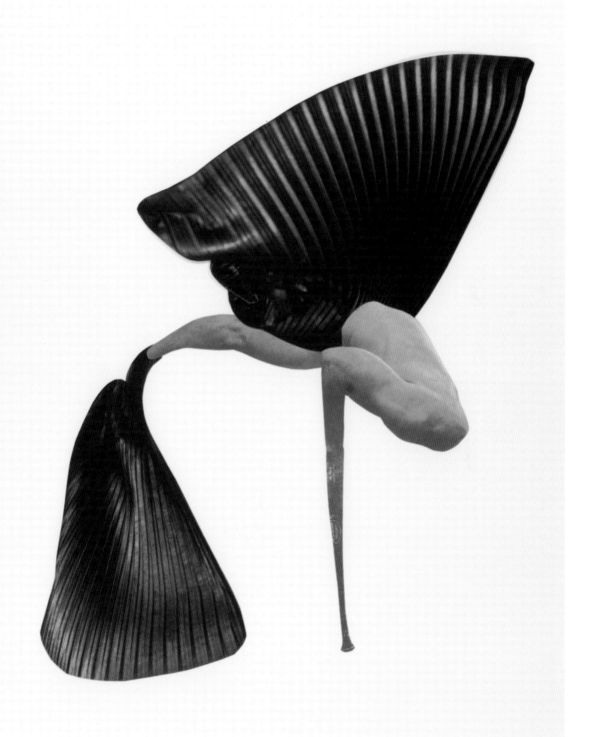

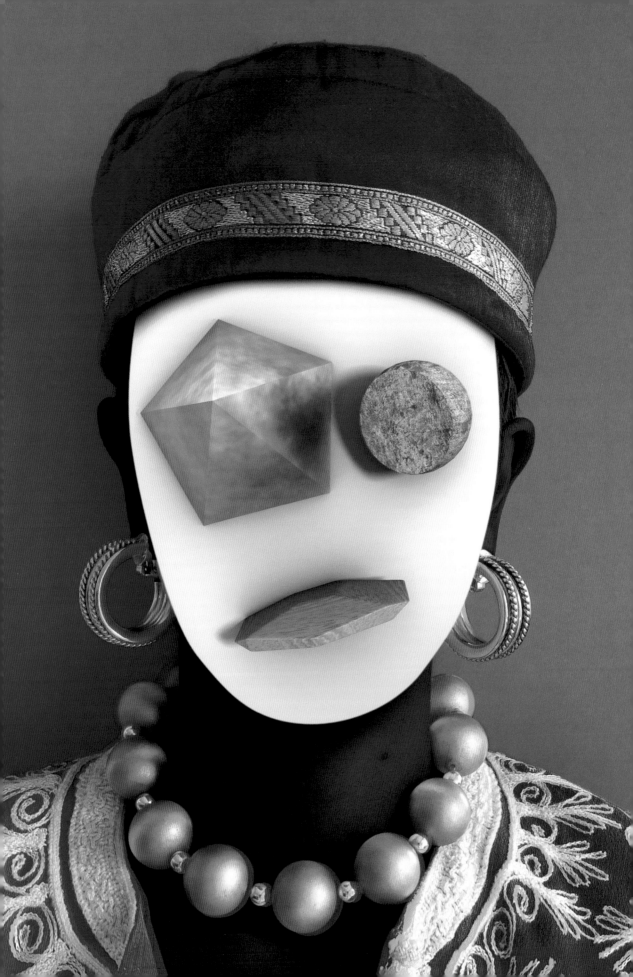

13

MARKUS HOFKO

Humour plays a big part in designer, artist and musician Markus Hofko (aka The Rainbowmonkey)'s work. He loves the random nature of collage and the unpredictability of the outcome: 'I guess it's some kind of absurdity. A surreal factor that makes us wonder. It's the unseen and surprising. A clash of things that don't belong together but suddenly do. It's fun.' Born in Germany but now residing in New Zealand, Hofko is involved in many side projects as well as his commissioned work; one of these is the music project Okyo, for which he designed a website homepage featuring a mask with five different interchangeable elements and 7,776 possible combinations. He loves the freedom of expression and narrative possibilities that collage offers: 'It's about building metaphors and often leads to an abstract execution. But you can also merge a lot of information into one image and tell a big story.'

Previous page
Spatio Temporel, cover artwork, dÉbruit EP, photography/3D, 2009

Below
7776 Masks, for Okyo interactive website, 2008

Opposite (top)
Poster for Okyo, photography/digital illustration, 2008

Opposite (bottom)
Chiffre, photography/ digital illustration, 2007

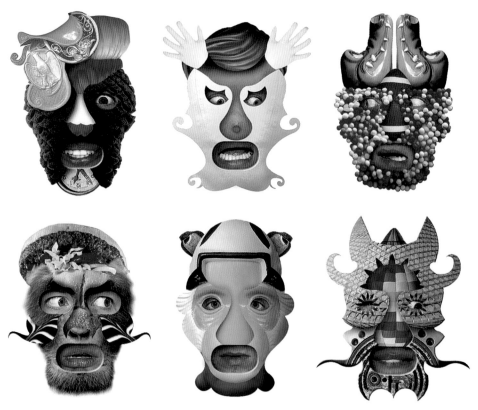

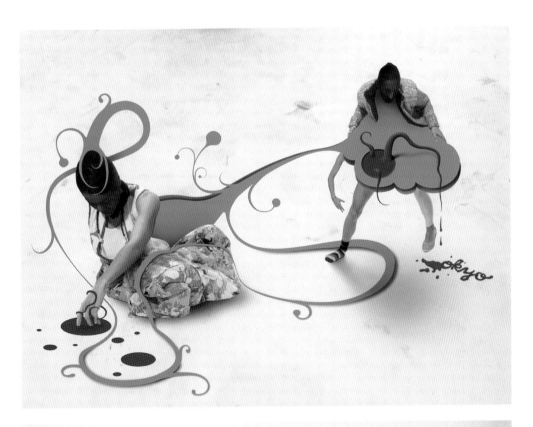

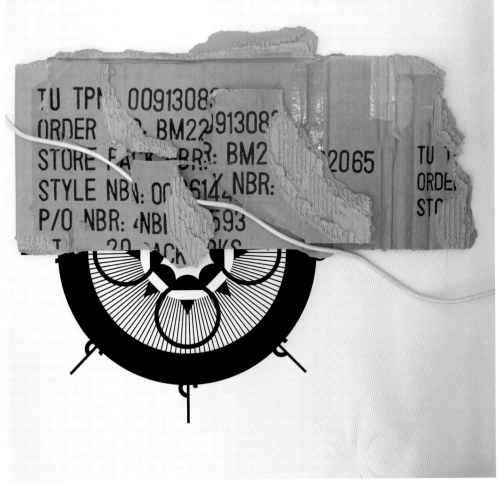

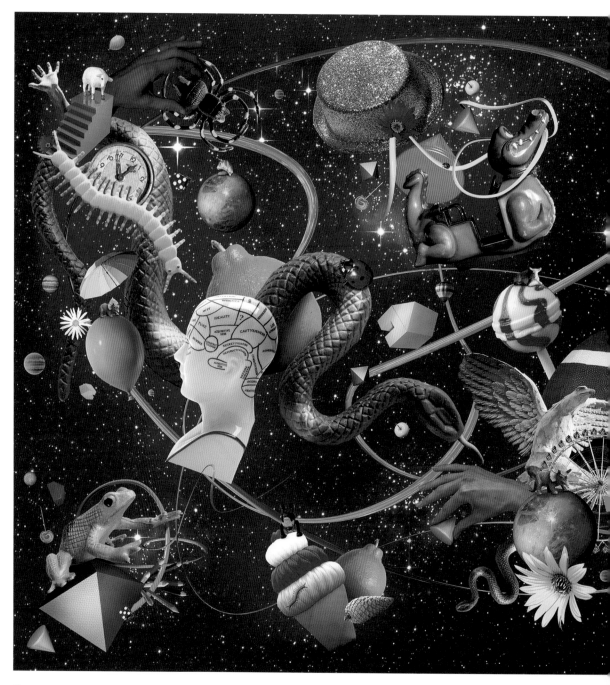

Below
Making Worlds,
photography/3D,
2007 (courtesy
of the Auckland
Art Gallery)

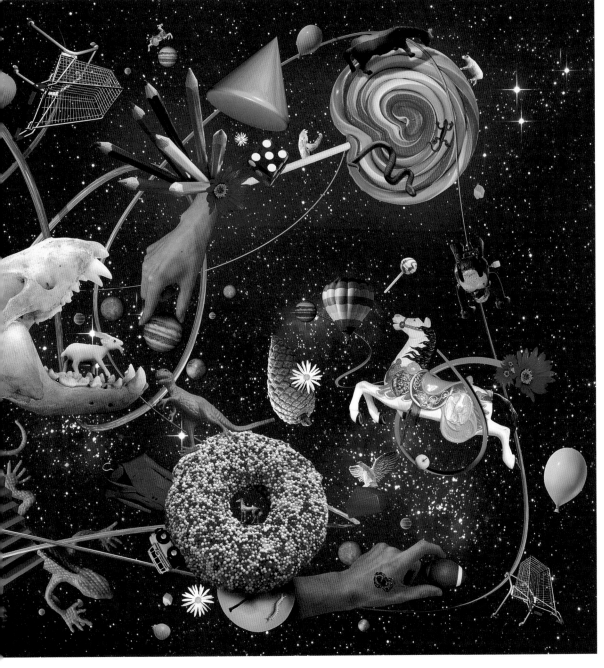

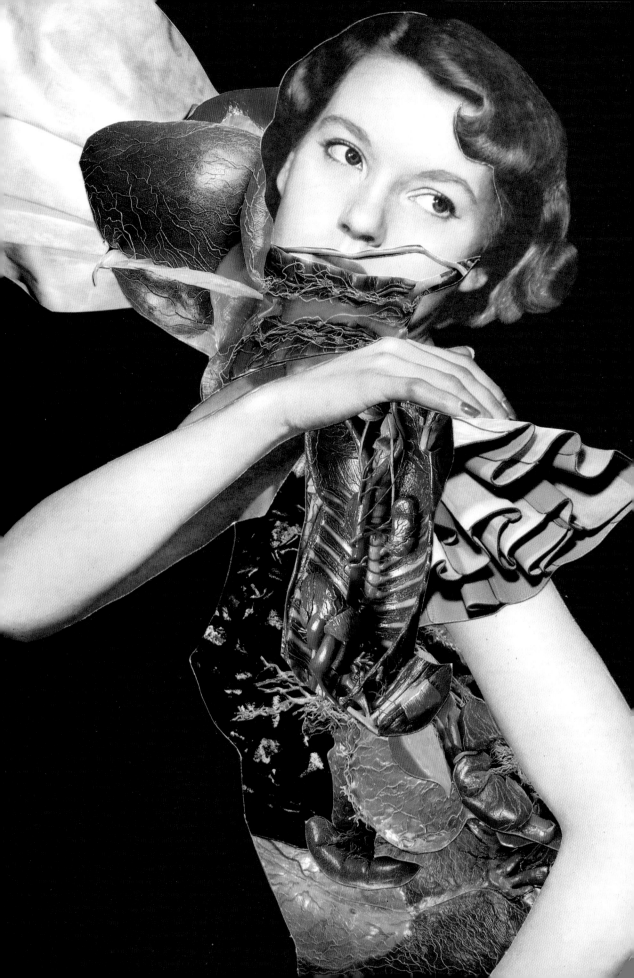

14

ASHKAN HONARVAR

Iranian-born, Utrecht-based Ashkan Honarvar's often sombre collages are primarily concerned with the human form: 'I always play with the human body, creating deformations through collage technique.' He takes inspiration from the hard-to-source vintage medical imagery that he collects, much of which is war-related. Working strictly by hand, he explains that sometimes he feels like a surgeon, 'with my scalpel and the human forms I am cutting and modifying'. In his disturbing 'Faces' series he sliced and put together disfigured faces of First World War veterans to represent the face of war and misery. His 'Finding Hitler' project found him examining the concept of evil through a series of very graphic cut-and-paste anatomical collages: 'Again, like a surgeon, I tried to go inside different body parts to find the roots of evil.'

Previous page
Ubakagi, collage,
2010

Right
Faces, collage,
2010

Below
Hate Machine,
collage, 2006

Opposite
War Dog,
collage, 2006

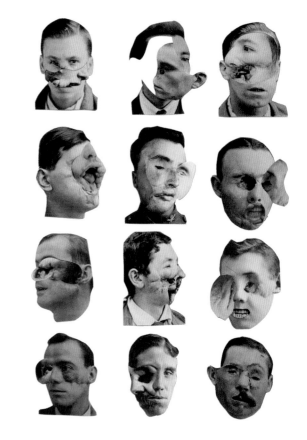

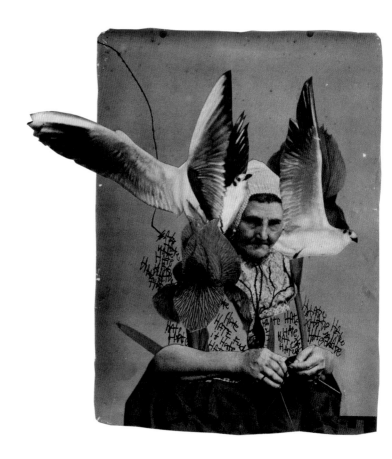

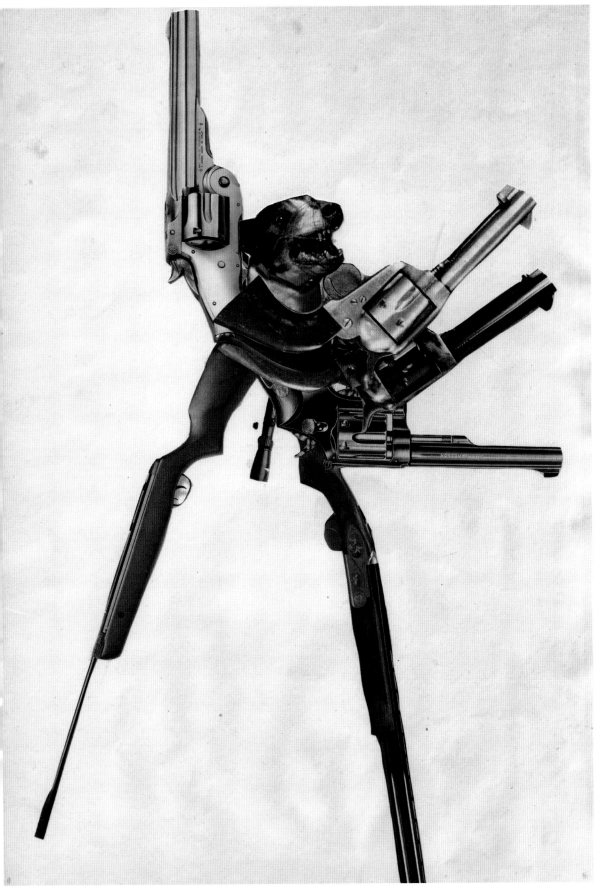

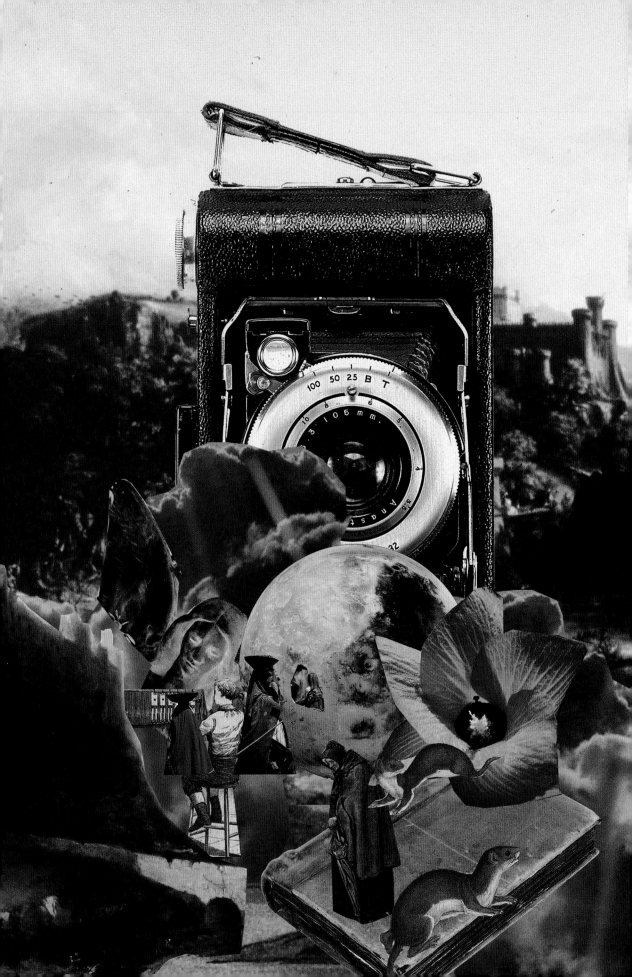

15

JULIAN HOUSE

Known best for his cover art and Ghost Box record label, London-based designer Julian House's collages have found their way onto many album covers. He uses a mixture of self-generated and found imagery, and a combination of analogue and digital techniques, but works quickly to keep the rawness and sense of spontaneity. He puts all of his images through a process of colour grading or treatment, which helps to divorce them from reality and create different tones and textures that play off each other. It's this clever juxtaposition of texture and manipulation of scale that makes House's work so engaging. He creates 'micro and macro' worlds within his work that are totally convincing, yet at the same time completely alien: 'I'm inspired by the way collage plays with time and space, creates strange portals that suck one reality into another.'

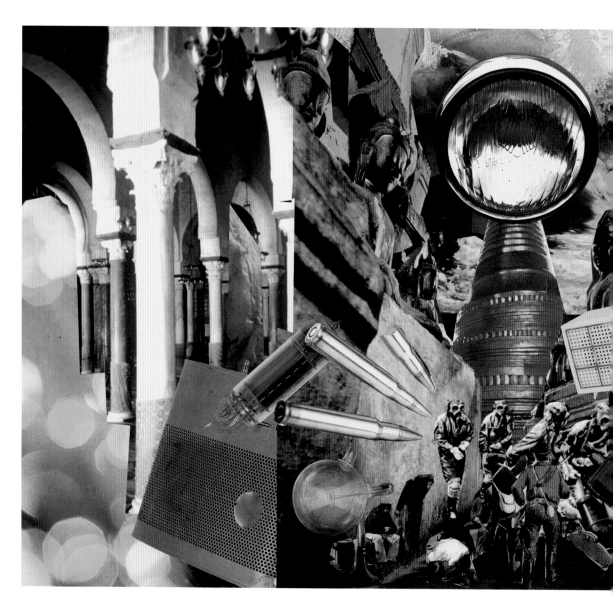

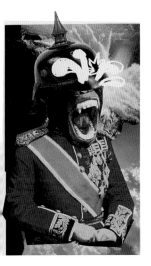
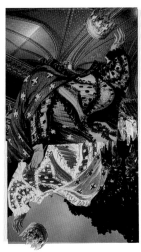
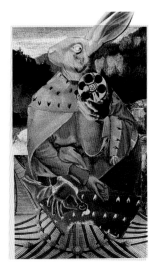
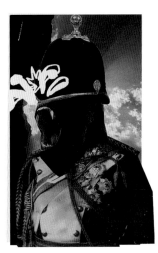

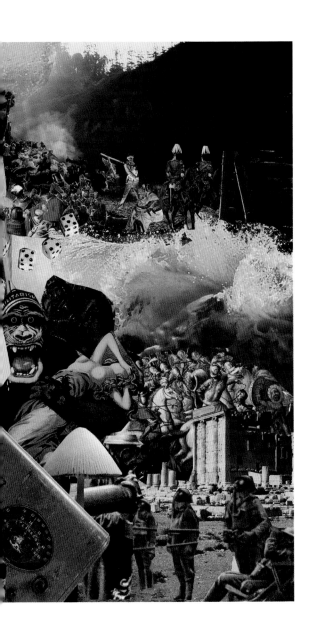

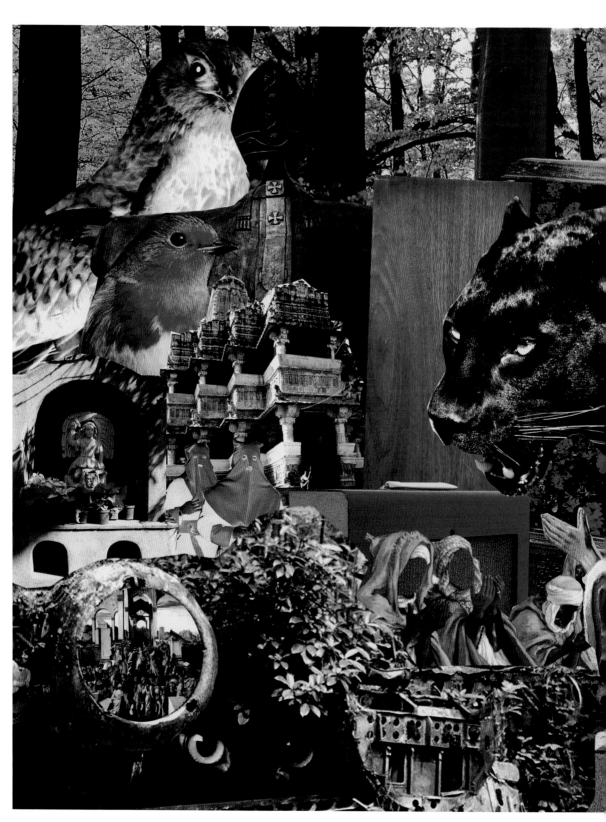

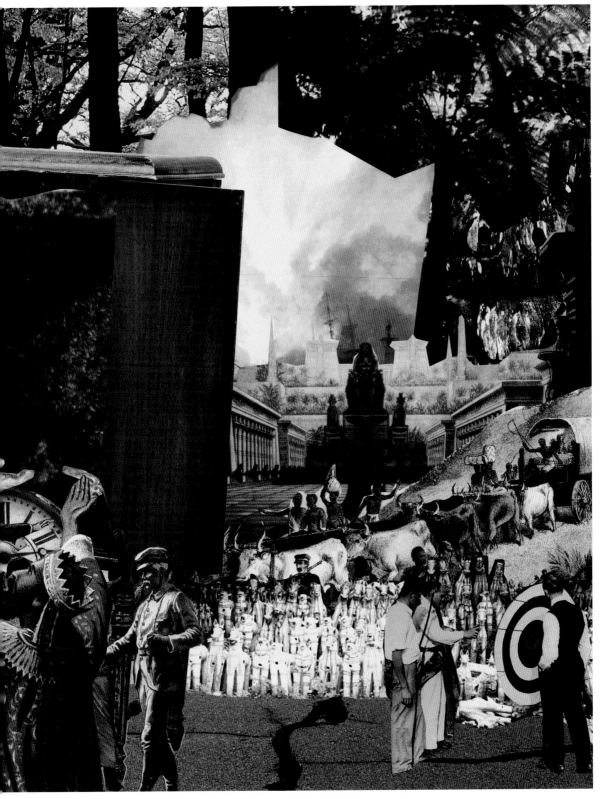

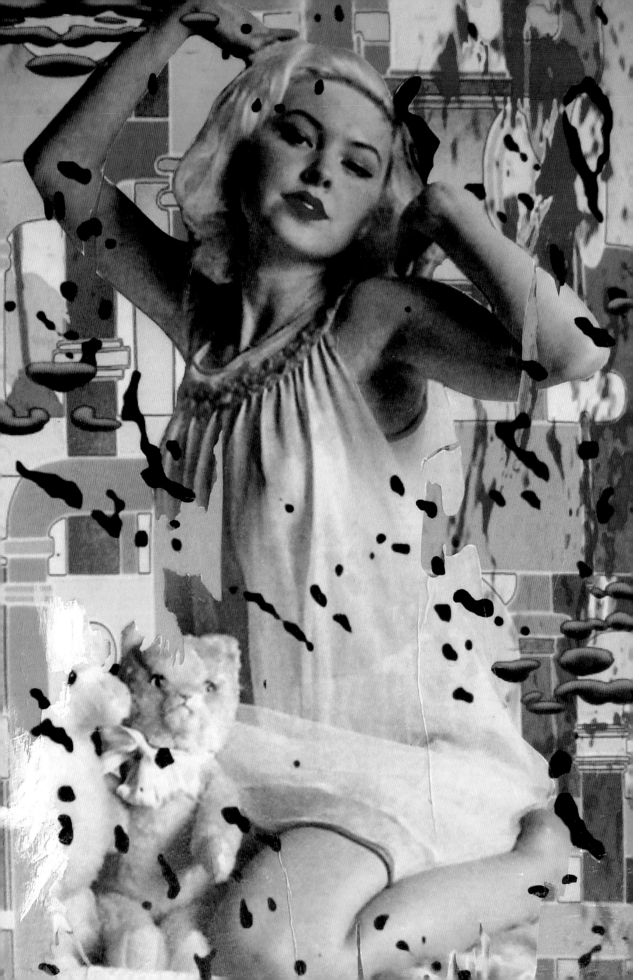

16

NATHAN JAMES

London-based artist Nathan James primarily uses collage as a tool to create his compositions, working digitally then recreating the image on canvas: 'When I've got something I can work with I'll print it, grid it up and start to work on the canvas with paint. The finished product is often very different from the idea I started with.' His energetic pieces are packed with images associated with youth culture, such as kids partying and skateboard graphics, as well as nostalgic elements such as vintage fabric and wallpaper prints. Cartoon imagery also plays a big part, with comic sound effects like 'Splank', 'Skrunk' and 'Voomp' all making an appearance. He loves both their graphic quality and the ambivalent statement that they seem to make: 'Being nonsensical, they don't push the meaning of the work in any particular direction.'

Previous page
Untitled, mixed
media collage
on board, 2009

Right
Nouveau Riche,
oil on linen, 2008

Below
Untitled, mixed
media collage
on board, 2009

Opposite
Untitled, mixed
media collage
on board, 2009

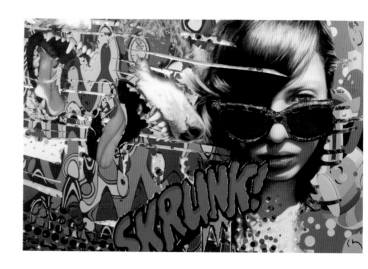

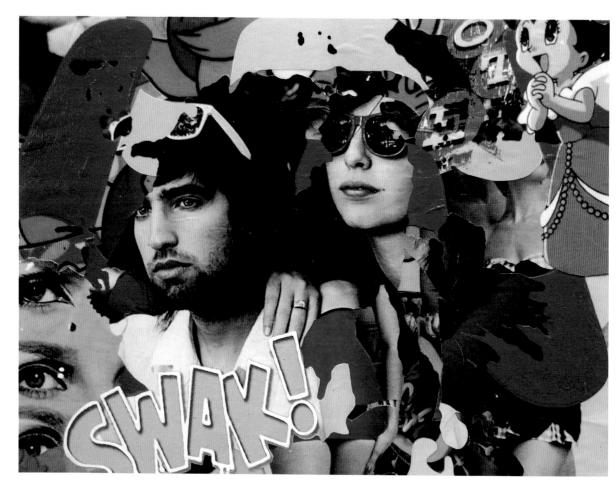

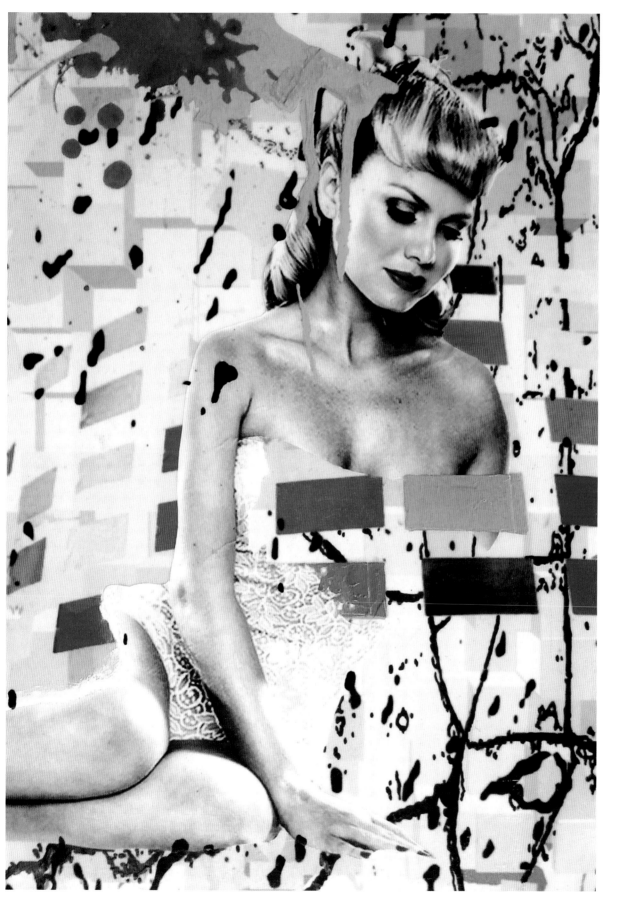

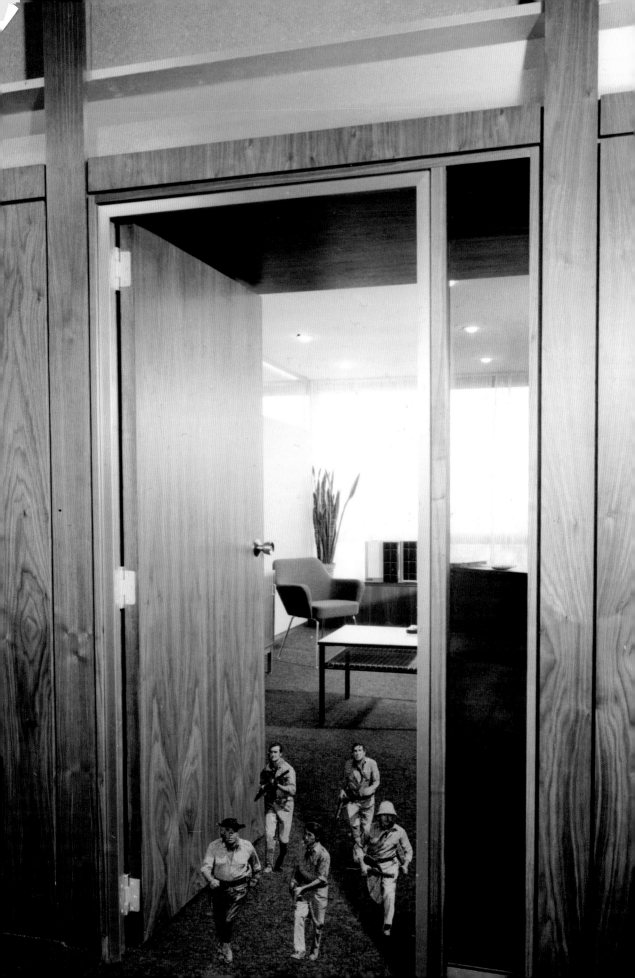

17

∙⊱✂⊰∙

PHILIPPE JUSFORGUES

There's rather a 'freakshow' quality
to much of Philippe Jusforgues's
photomontages. What appear at first
glance to be formal portraits or family
snapshots have been manipulated,
sometimes to create a subtle change,
other times to form grotesque faces
that look like the results of a scientific
experiment that's gone badly wrong.
He discovered a rich source of material
when he came across a suitcase full of
old family photographs, and he uses a
mixture of drawing and collage: 'I work
with pictures. Sometimes I "attack"
them directly with ink, but collage is
the most recurring method. Collage
wasn't part of my artistic culture, I had
no reference to it, and that's certainly a
reason why I've enjoyed it. I feel more
free.' He also feels that collage offers a
way to express humour: 'The collage
process carries with it a lightness,
which brings out the humour. It's like
hallucinations solidified in reality.'

Previous page
Untitled ('Série Noire'), collage on vintage photograph, 2008

Right
Untitled ('Renaissance' series), collage on vintage photograph, 2007

Below
Untitled ('Renaissance' series), collage on vintage photograph, 2007

Opposite
Untitled ('Série Noire'), collage on vintage photograph, 2008

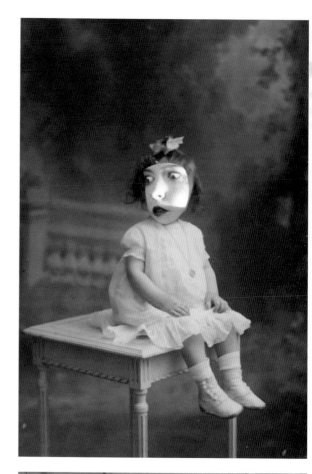

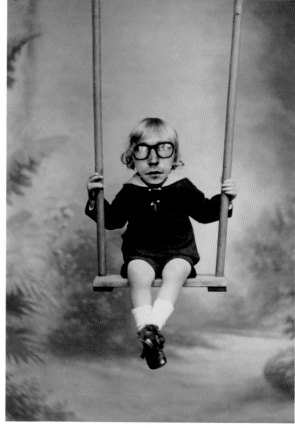

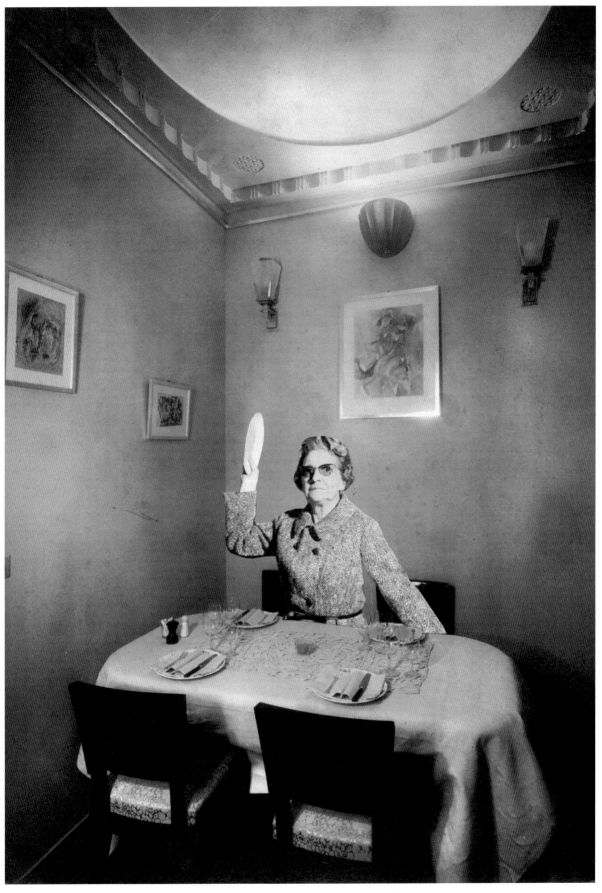

Below
Untitled (BRIO
series), collage on
vintage photograph,
2007

Opposite
Untitled (BRIO
series), collage on
vintage photograph,
2007

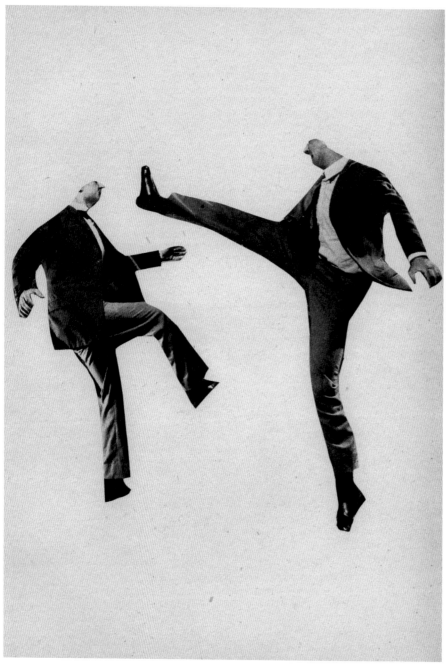

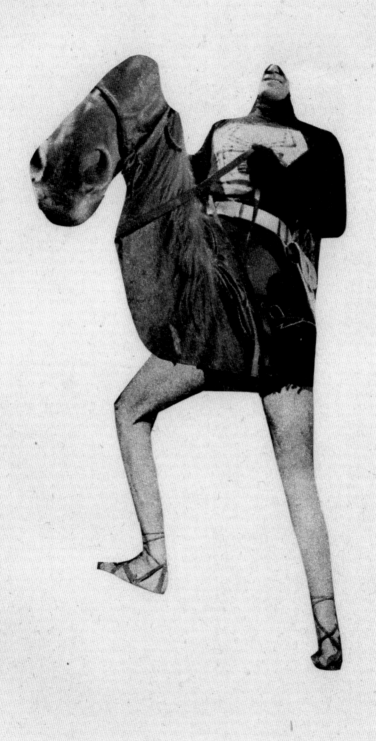

18

✂

VICTOR KAIFAS

Many people will be able to identify with Victor Kaifas's first experience of collage: 'When I was young I defaced mum and dad's newspapers with pens, tape and scissors. Lots of women with Chinese hats and long whiskers', but he soon graduated to stronger stuff. Drawn to old Hollywood glamour, tribal Africa and skinheads, he admits to feeling 'more like a taxidermist as time goes by – I seem to tart up the dead'. Collage has given him a way of expressing himself that he previously found lacking, explaining that, to him, 'Traditional painting and drawing smells like a nursing home', and he thrives on the random element: 'It's like tuning a radio, all that distortion, different meanings, sounds, loose, accidental connections.' Much of Kaifas's work concerns the human form and he finds inspiration in unusual places: 'I've found amateur porn sites throw up bodies and poses I previously thought impossible.'

Previous page
Blue Sinéad,
screenprint and
mixed media, 2009

Right
Sing Launa,
screenprint, 2010

Opposite
Mia, screenprint,
2010

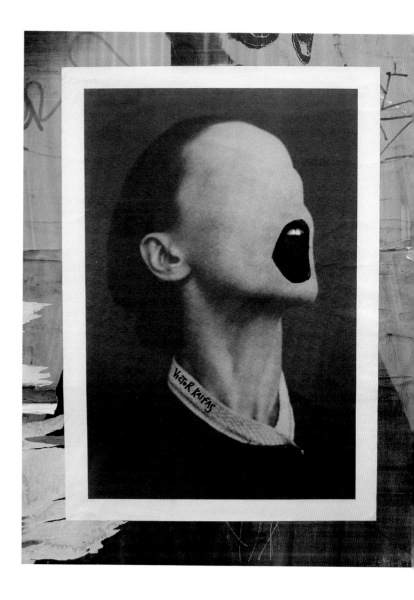

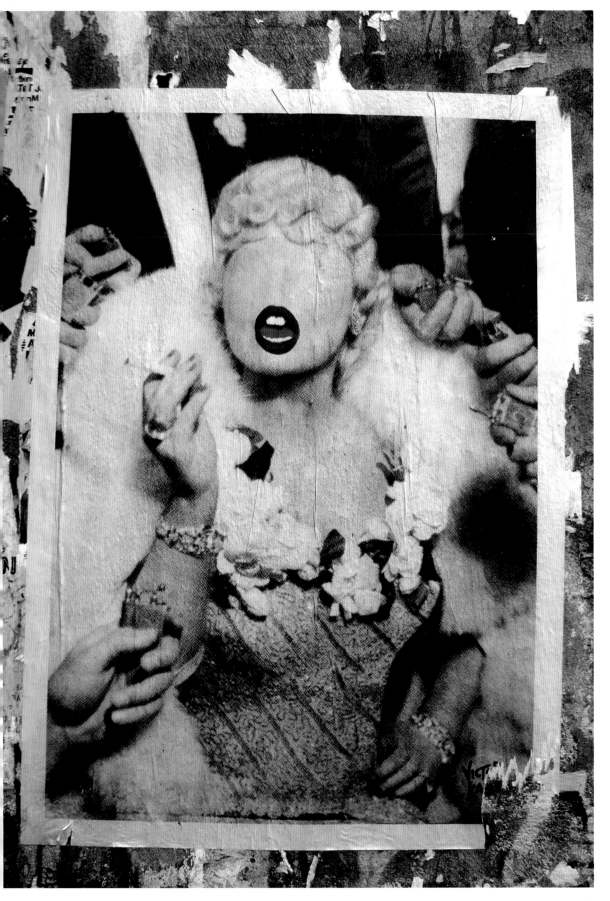

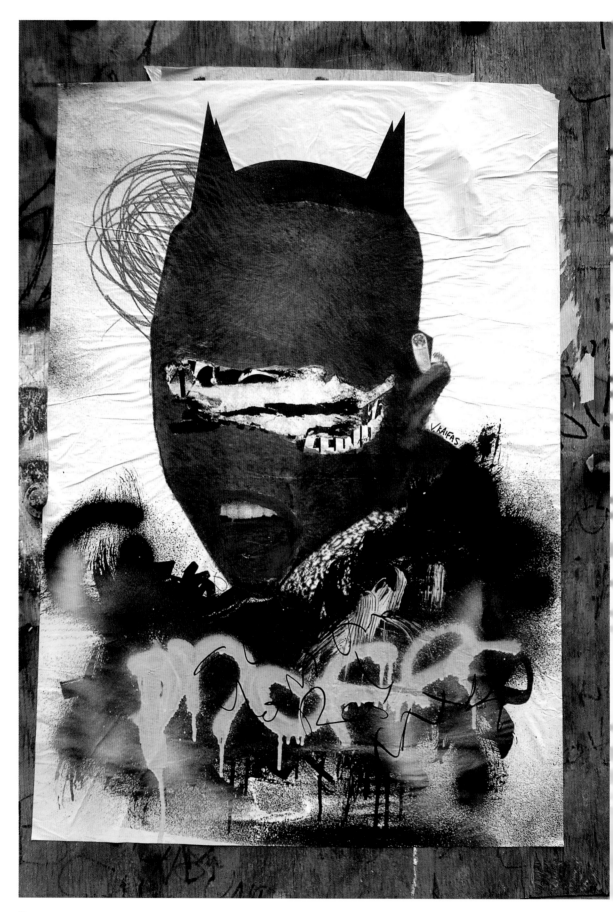

Opposite

Red Sinéad,
screenprint and
mixed media, 2009

Right

Ergo, screenprint,
2010

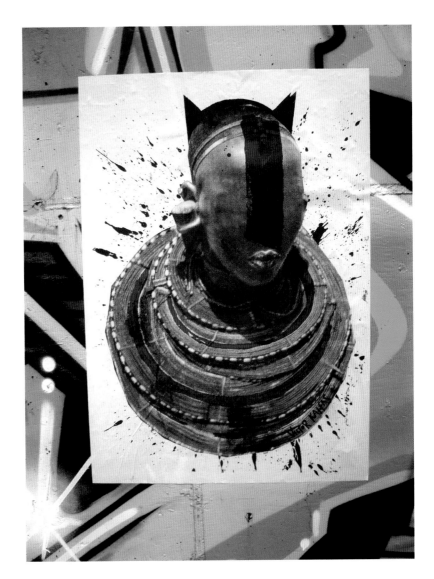

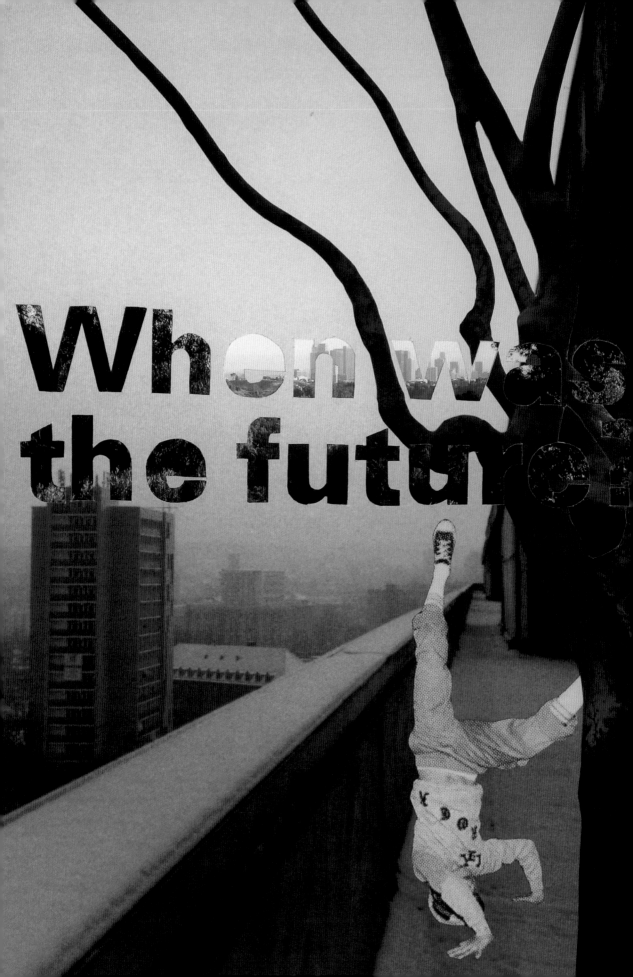

19

JAKOB KOLDING

The idea of landscape plays a big part in Berlin-based Jakob Kolding's gritty pieces: 'In terms of subject, the work has gone from a relatively specific interest in modernist utopias and suburban space, to a more general interest in urban space.' He likes the fact that every element used references something outside of the work, making for a multilayered and complex experience. He is acutely aware that context always matters and enjoys playing around with this in 'simple yet meaningful ways'. Collage is always at the heart of his creative process and he admits that 'even when the work doesn't look like a collage, that is basically still how I think about it. I like how in the process you can build up your own vocabulary, something very personal but made out of only found images. Nothing comes from nothing.'

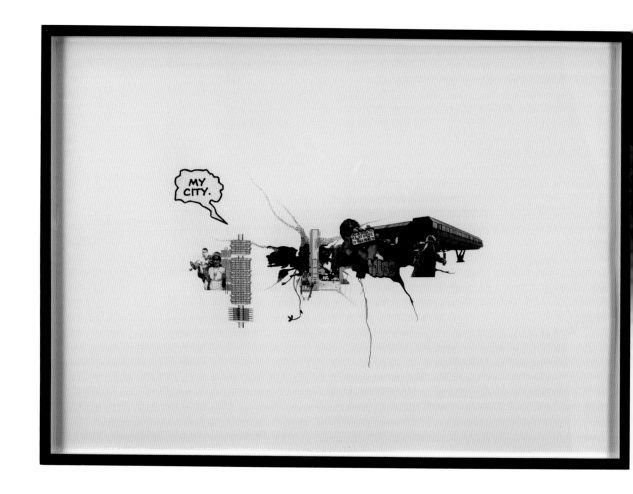

Previous page
When Was the Future?
2008 (courtesy of
Team Gallery,
New York)

Above
My City, collage
and drawing on paper,
2008 (courtesy
of Team Gallery,
New York)

Opposite
Round-Up, collage
and drawing on paper,
2008 (courtesy
of Team Gallery,
New York)

100

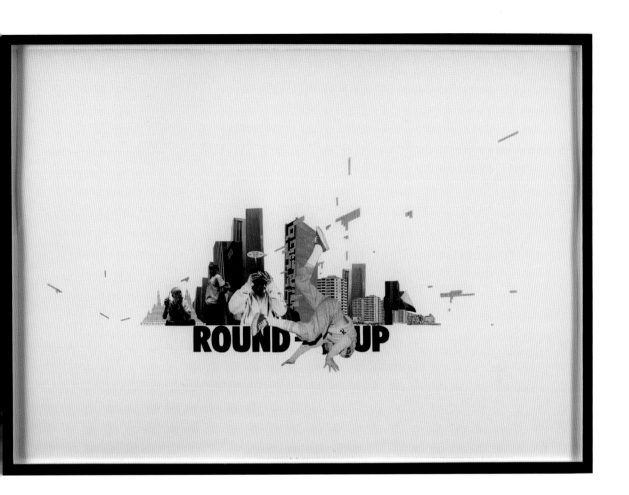

20

KRAFFHICS

Located in Leeds, photography-based
art collective Kraffhics consists of art
director Leemun Smith, graphic designer
Matt Reid, illustrator Daniel Cantrell
and photography director Kirst Wilson.
Kraffhics's varied work encompasses
collage, graphic design, illustration
and small-scale set design. Smith is
responsible for the cut-and-paste pieces
– his energetic, streetwise collage work
combines vibrant colours and lively
images. Smith takes his inspiration from
the different materials that he collects,
and he always photographs the final
piece: 'I like it all to be there in front
of me, not superimposing anything with
Photoshop. I photograph the image I
have made and use strong lights to get
the colours. When I get a big print made
of my work it looks like the original, you
can see the real shadows or the cut-out
paper, and I get a much stronger image.'

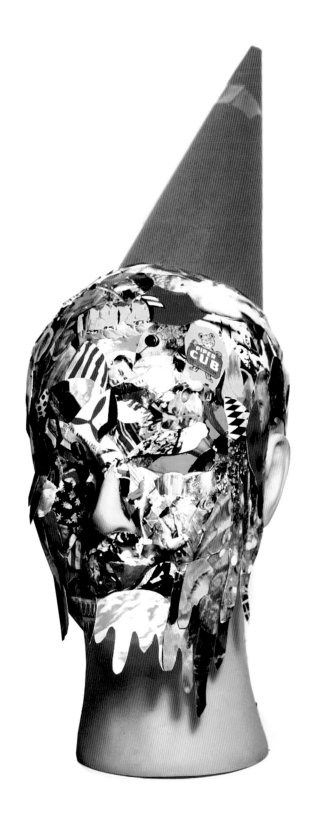

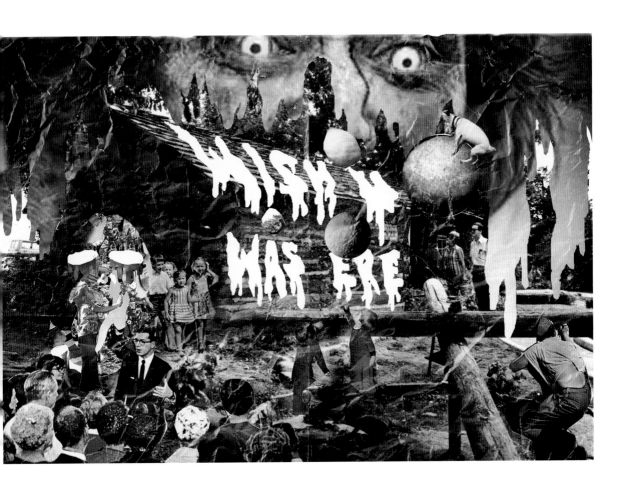

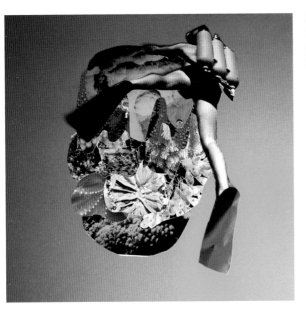

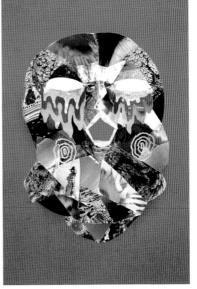

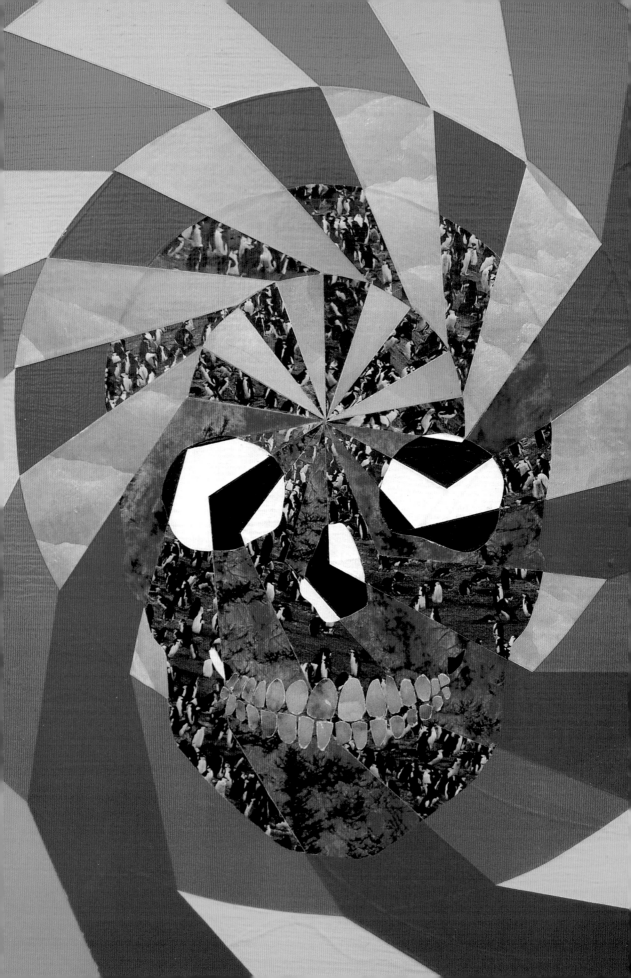

21

MICHAEL LAZARUS

Collage has become an increasingly important part of artist Michael Lazarus's work. For many years he used it in a 'somewhat visually covert way' using simple images and textures in subtle ways. Recently he has used it in a far more overt way, with recognizable images such as signs playing a much bigger part in his work. Based in Portland, Oregon, his bold, decorative pieces have an almost tribal feel to them. The technique he uses gives his work a very precise, graphic quality: 'I generally prefer to cut out the paper into the shape it needs to take, rather than paint over parts of the paper. For me, this helps it to operate as a "piece" of or in the work, rather than something that has been put on top of or imposed onto the work.'

Previous page
Nobodies Business (detail), acrylic and collage on wood, 2008 (courtesy of Brennan & Griffin, New York)

Right
Paradoxical (detail), enamel, collage and mirror on wood, 2007 (courtesy of Brennan & Griffin, New York)

Below
Free (detail), acrylic and collage on wood, 2009 (courtesy of Elizabeth Leach Gallery, Portland)

Opposite
Push (detail), acrylic and collage on wood, 2009 (courtesy of Elizabeth Leach Gallery, Portland)

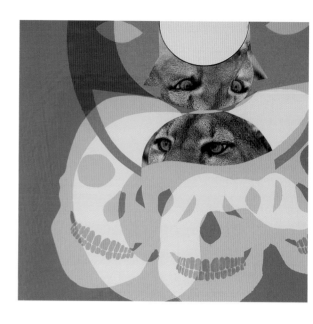

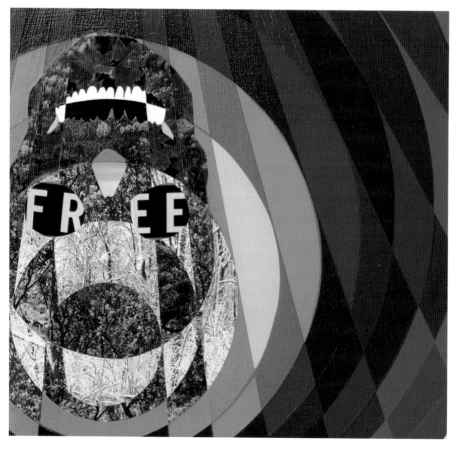

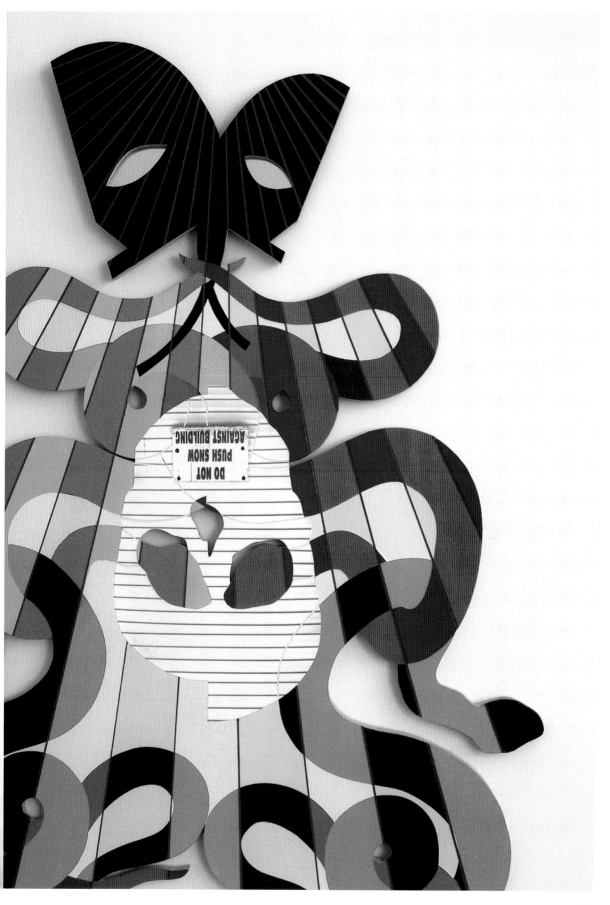

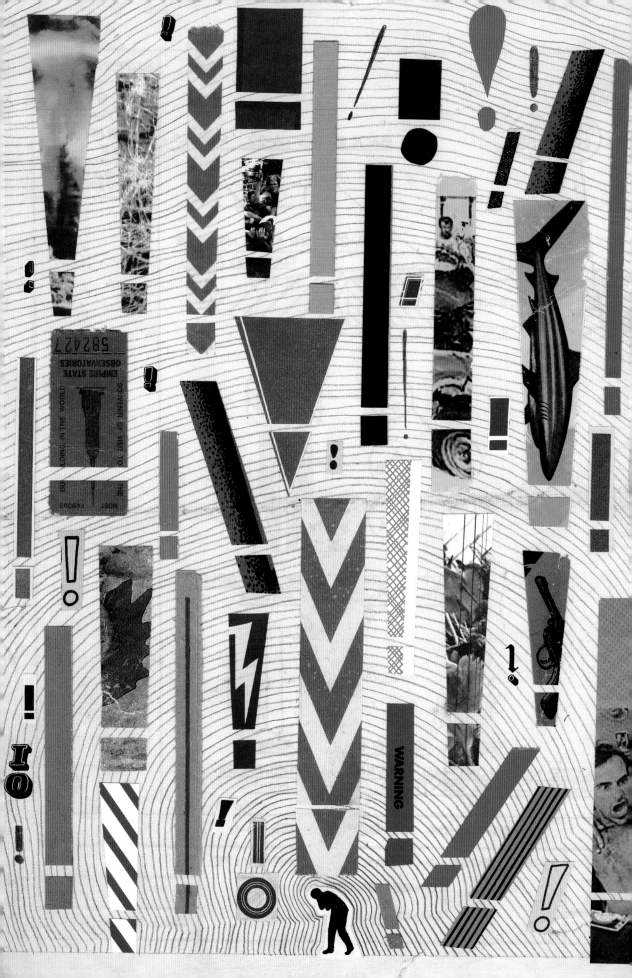

22

MARK LAZENBY

Mark Lazenby's collages are constructed from 'any beautifully badly printed matter of any age'. To him, collage is a way to make something beautiful from something unimportant: 'There is so much beauty and truth in the things we disregard, I seek to rescue and elevate these fragments.' His work juxtaposes the sacred and the profane – bits of rubbish are mixed with newspaper and antique paper, creating 'moments of profound clarity and beauty amongst the everyday red herrings'. Lazenby's work is based on layers – of meaning and of paper – and he sees his work as visual poetry: 'I want all my work to be beautiful, visually alluring, and then to reveal itself, the ideas and narrative gradually. It is about nostalgia, salvation, longing for the past and for the future, about fragments and building worlds from these fragments.'

Previous page
Fear Factor, for *Vogue
Australia*, collage,
pencil, Letraset, 2006

Below, left
I Look to the Hills,
collage, 2007

Below, right
Pleasant Mountain,
collage, 2007

Opposite, top
Love (J&P), collage,
cotton, pencil, 2009

Opposite, below
Noah Shine as a Star,
collage, pencil, 2008

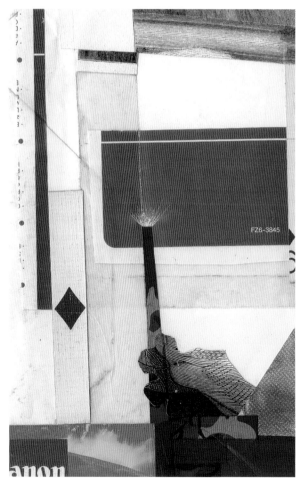

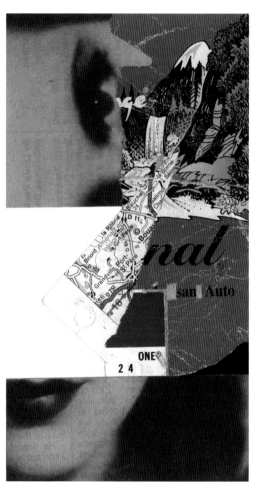

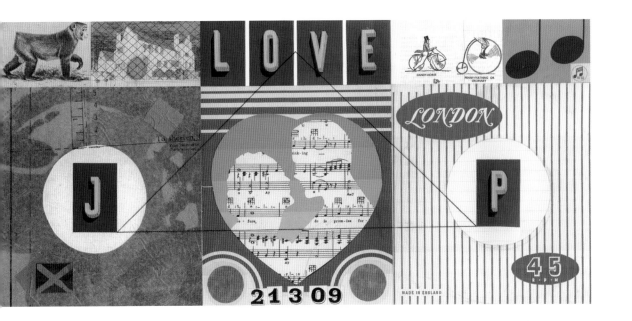

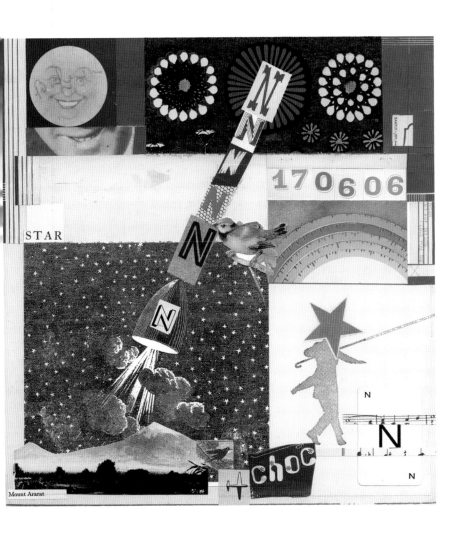

Below
Tilly Losch album
artwork, collage,
2008

Opposite
*Fixed to be Fixed and
the Need to be Broken,*
collage, 2002

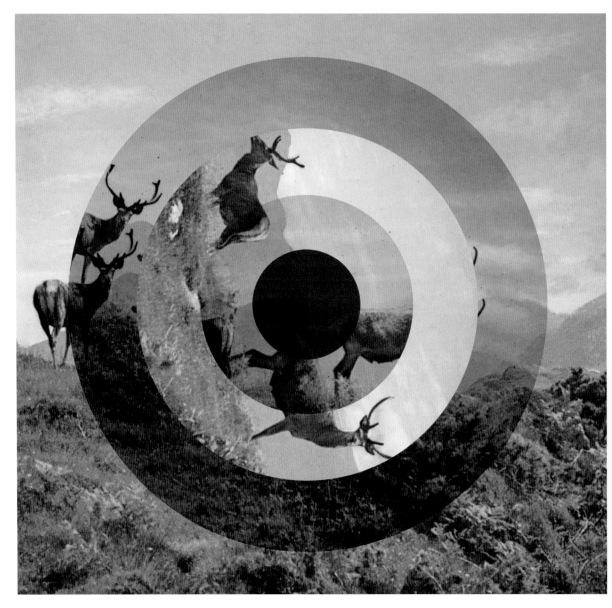

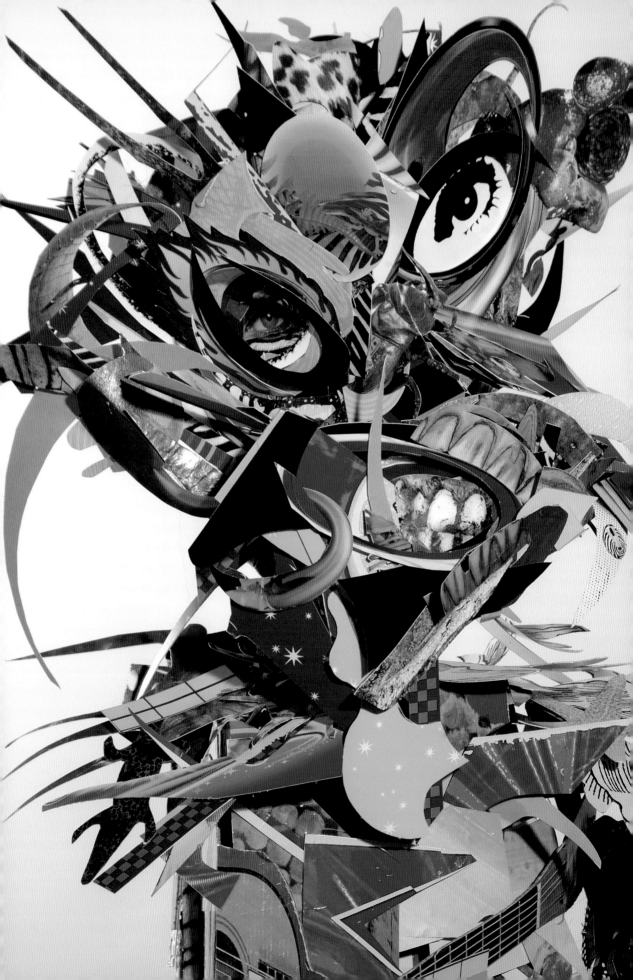

23

PEPE MAR

Mexican-born, Miami-based Pepe Mar's vigorous 'fetishistic tribal mechanical' techno-influenced cut-and-paste work is full of acid colours, sharp edges, and patterns and textures taken from beer and soft drinks packaging. He likens the process of making his pieces to that of making music using a sampler: 'I think everything will be collage in the future, the same way music is becoming about sampling different beats. As the world continues to become smaller in distance and information, the access to more and more elements that could be used for collage becomes greater.' He also creates striking sculptures, which are a natural extension of his 2D work: 'I always work with collage, but it occasionally becomes assemblage. I like 3D because most of my pieces are more akin to sculpture, kind of like a pop-up book.'

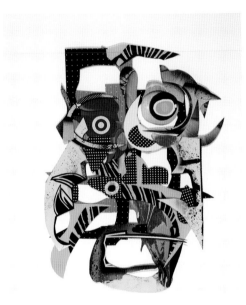
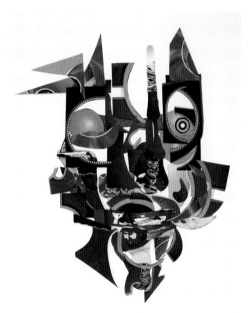

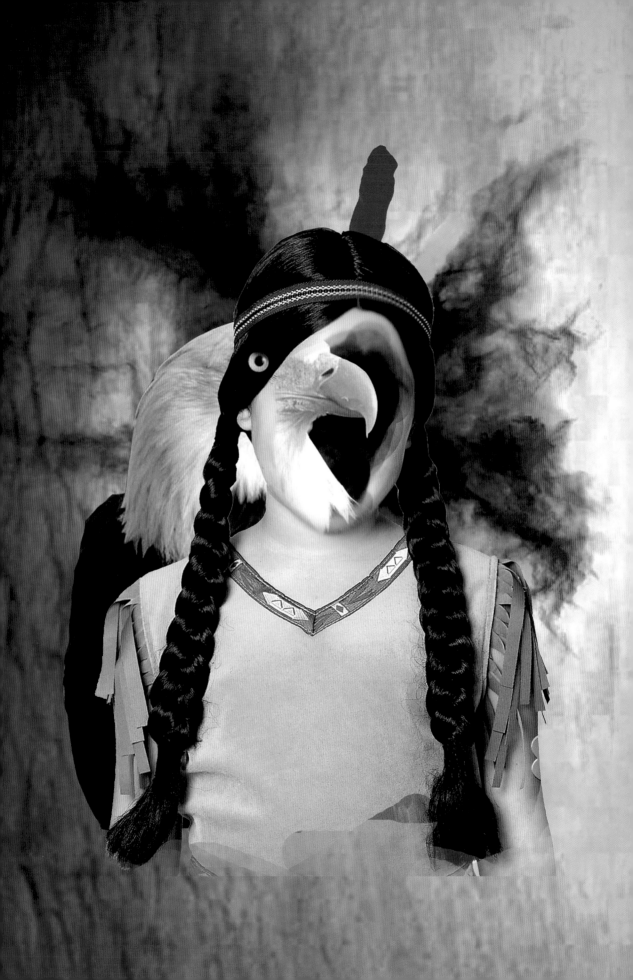

THEO MERCIER

Birds of prey, kittens, body parts, owl masks, Indian squaws – it's all fair game as far as French collage artist Théo Mercier is concerned. Is there any method in this Surrealist-inspired madness? It's obvious there is, but he's not letting on. As well as collages, Mercier creates large-scale sculptural pieces and installations, which he also photographs: 'I like the idea of a dialogue between media. I tell a lot of stories about objects and spaces with photography. A lot of my first works were pictures of installations and sculptures, but it was mainly because of economic and technical reasons.' As well as his native Paris, Mercier has spent time in Berlin, New York and London. These different locations have all had an impact on his work, as the material that he gathers for his work from flea markets, junk shops and from the street is essentially part of the fabric of each city.

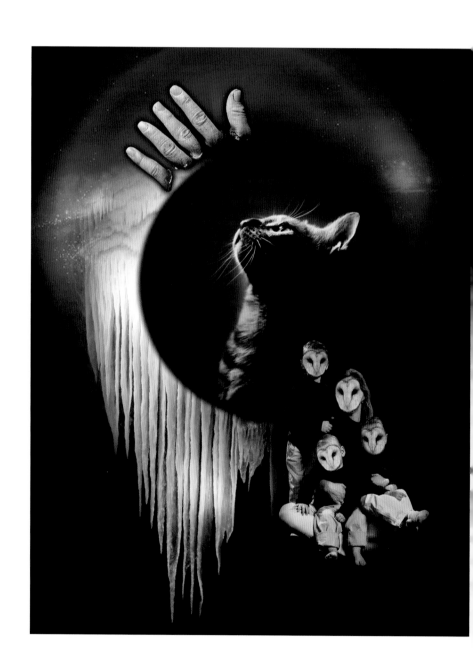

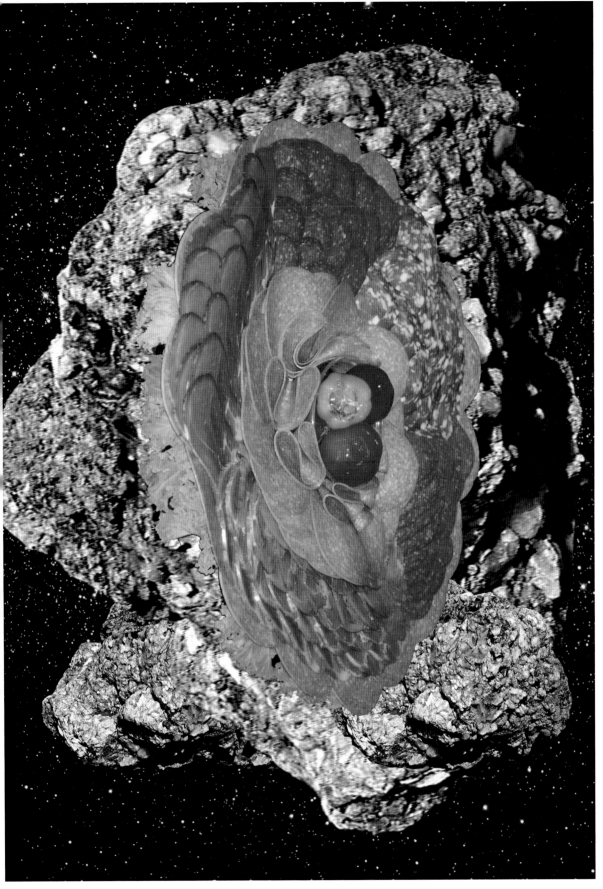

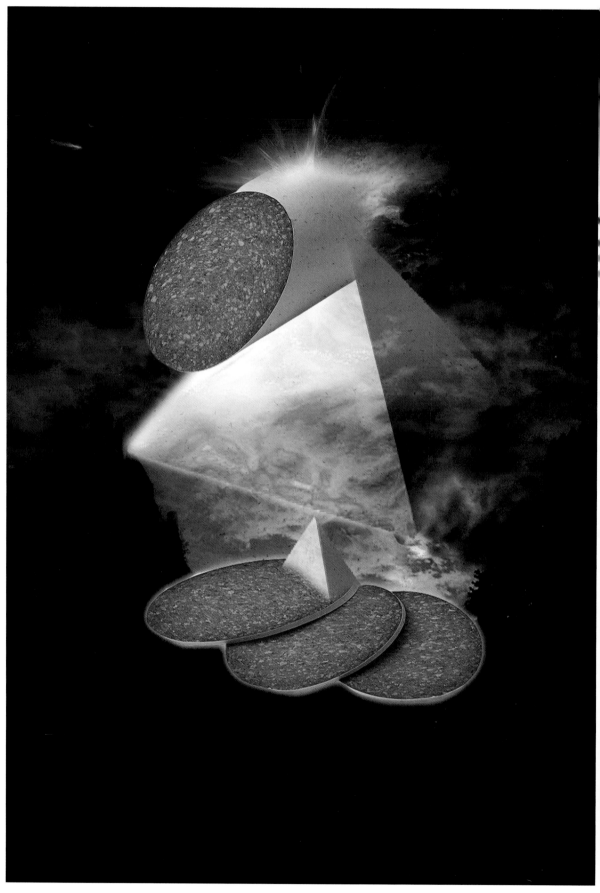

Opposite
Salem Salami, digital
collage, 2010

Right
Seaside, digital
collage, 2009

Below
Facelift, digital
collage, 2010

(all images courtesy
of the artist and
Envoy Enterprises,
New York)

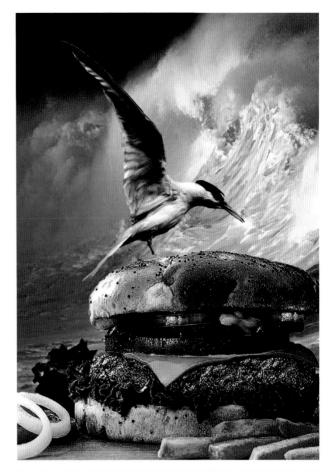

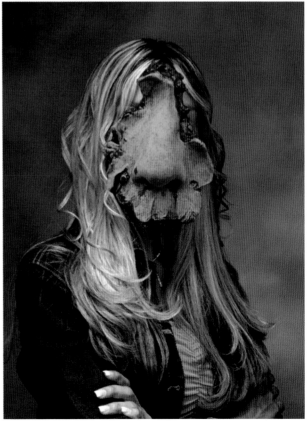

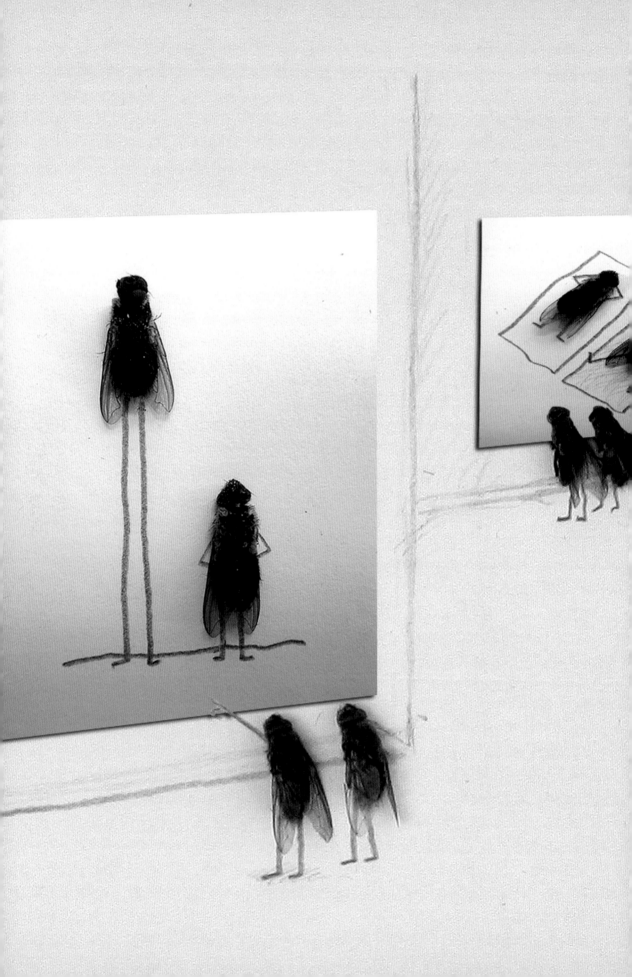

MAGNUS MUHR

Swedish photographer Magnus Muhr's irreverent fly pictures seem to really capture people's imaginations. He stumbled upon the idea by chance when he was at a party, went for a walk and came across a dead fly. He got home, put some flies on a piece of paper, drew legs, arms and backgrounds, and an internet sensation was born. The flies can be seen participating in all sorts of activities, from sunbathing to ice skating, and Muhr sees that they have a universal appeal: 'I think they've become popular as they are very simple and don't need any explanation, the language is international and the humour is about human feelings and activities.' No flies are hurt during the making of these pieces, as Muhr never kills the insects in his pictures – he keeps a collection from dead flies that he finds on windowsills and in lampshades.

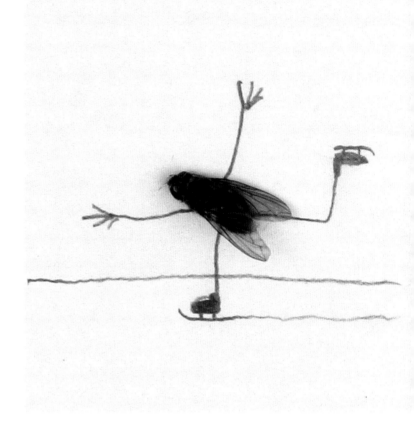

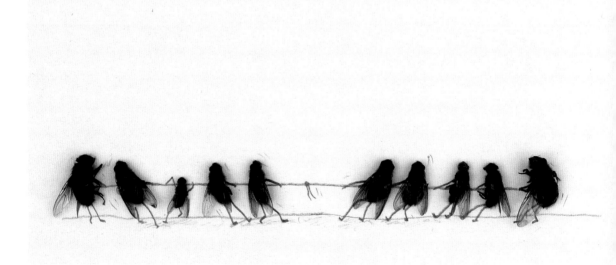

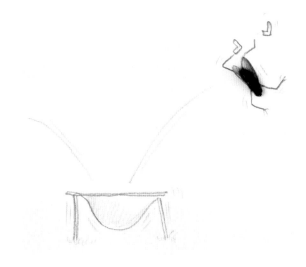

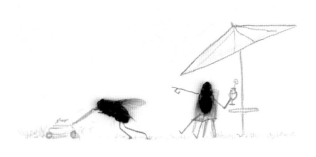

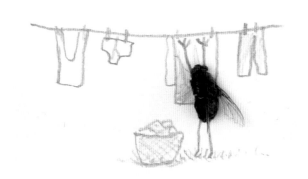

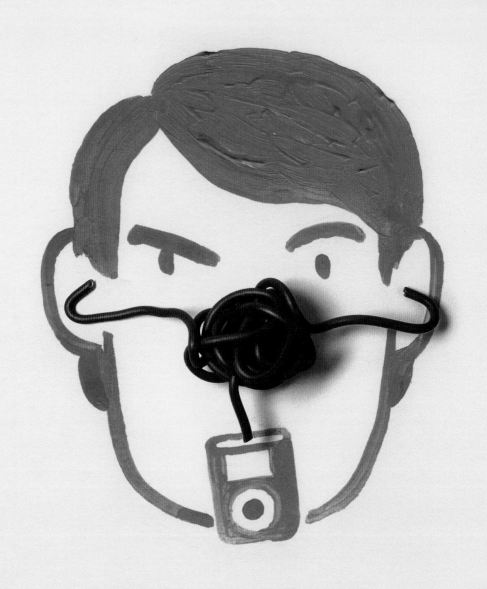

26

CHRISTOPH NIEMANN

Christoph Niemann is probably best
known for his distinctive covers for
the *New Yorker*, *Newsweek*, *Wired* and
the *New York Times Magazine*. After 12
years in New York City he has recently
decamped to Berlin. He isn't a big fan of
using other people's images, being a self-
confessed 'control freak and copyright
enthusiast'. He also admits to being a
'terrible photographer'. When he began
a series of blog posts called *Abstract
City* for the *New York Times* website, he
used a combination of drawing, painting
and real objects to illustrate his witty
and poignant observations on diverse
subjects ranging from the Berlin Wall to
insomnia. This analogue solution works
particularly well in his acutely observed
and beautifully illustrated pieces entitled
'My Life With Cables', which chart
a frustrating yet inevitable aspect of
modern life that we can all identify with.

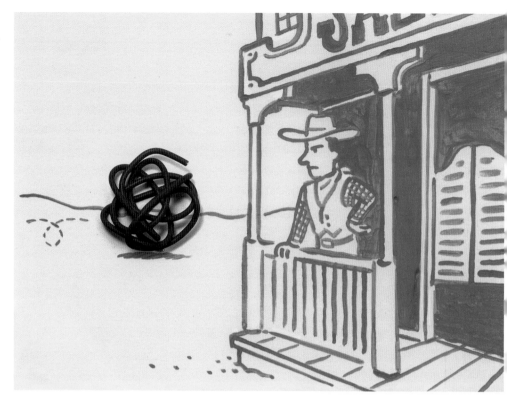

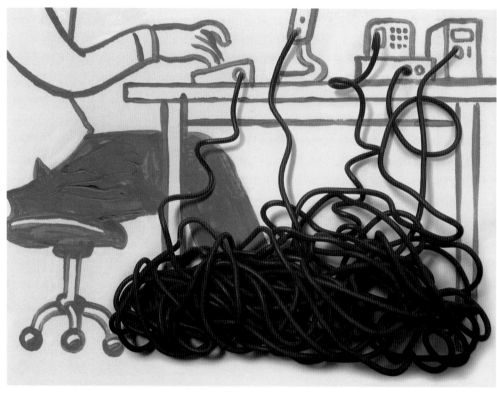

'Upon our arrival in Berlin, I realized that there were some extremely important cables woven into miles of headphones and other junk. Untangling this mess was impossible, unless I cut some evil $3 headphones. Then I realized that a crucial cellphone charger had an identically thin black cable: a situation that required steady hands and a bold heart.'

Below
'I am aware that I could reduce the number of cables in my life if I took advantage of all the advancements in wireless technology. The problem: if it's not attached to a cable, I will lose it. If my 24-inch computer screen wasn't connected to the wall with a power cable, it would disappear among the sofa pillows one day.'

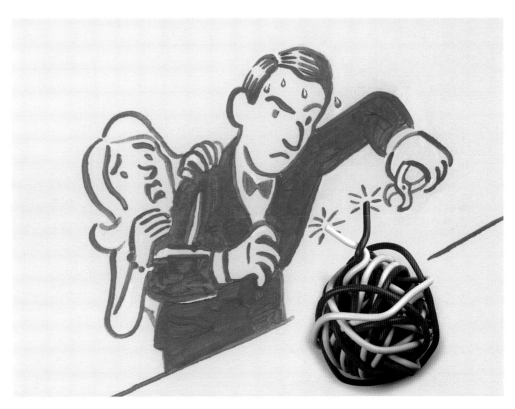

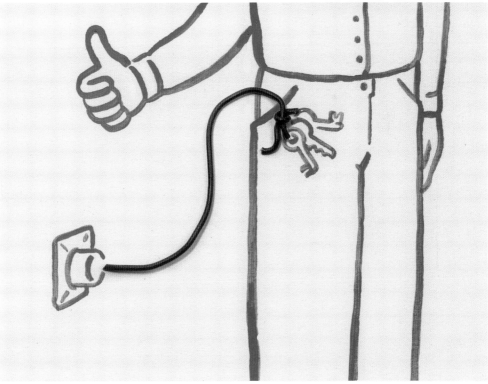

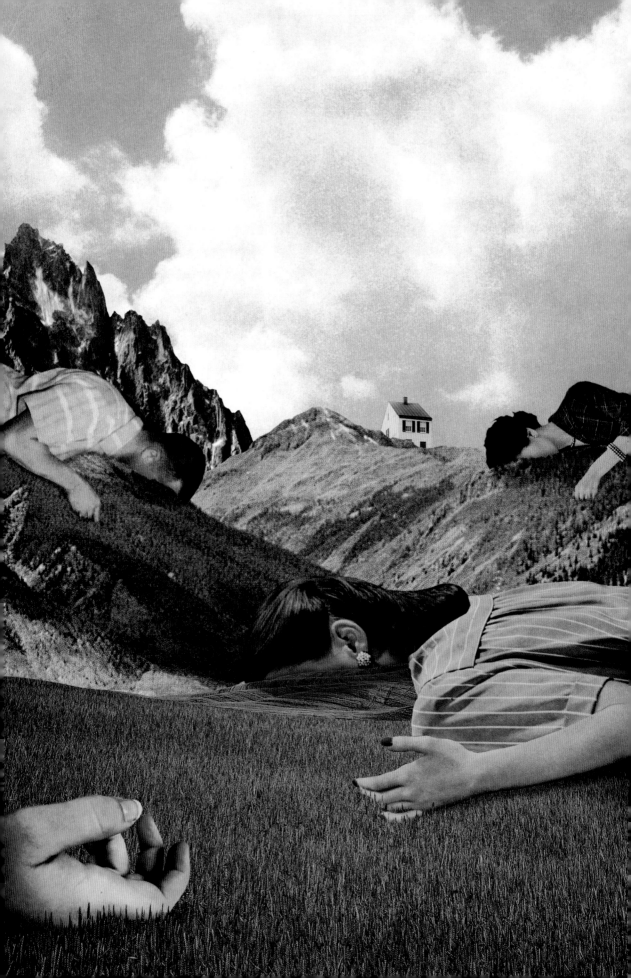

JULIEN PACAUD

Julien Pacaud is a French illustrator,
currently living in Le Mans, whose
artwork has been widely featured in
books, magazines and newspapers as well
as on calendars and music CDs. In his own
words, he has been 'an astrophysician,
an international snooker champion,
and a hypnotist', and hopes to one day
devote himself to his 'real passion: time
travel'... Pacaud's somewhat surreal
view of the world is evident in his
artwork, which layers cute retro imagery
with photography, creating art with a
disturbing, almost apocalyptic subtext.
Sumptuously coloured and often featuring
menacing iconography, the pieces invoke
a feeling of sensory overload. Several
of Pacaud's works build into a series to
create fascinating, unsettling narratives.

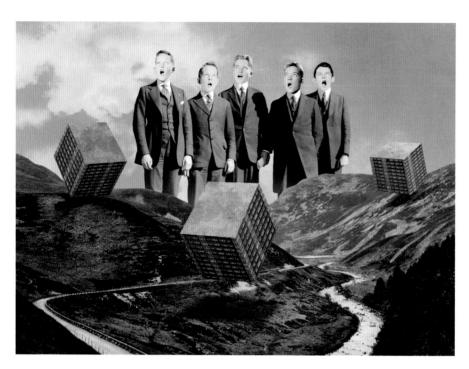

Previous page
When You Sleep, digital collage, 1991

Left
Incantation, digital collage, 2008

Right
The Jonas Project, digital collage, 2009

Opposite
Funny Games, illustration for *Milk* magazine, digital collage, 2009

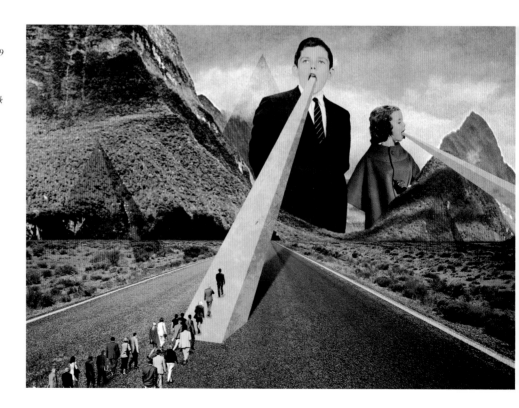

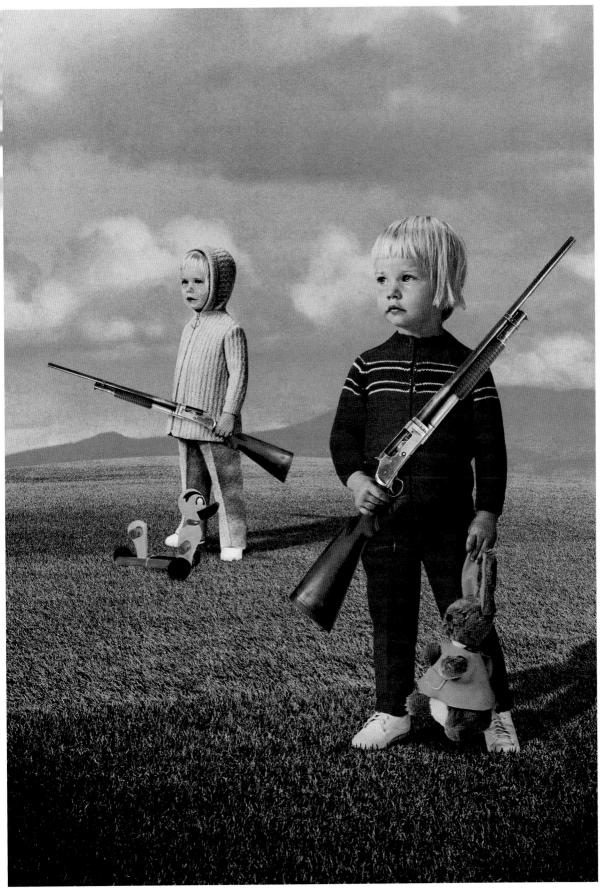

Below
Sous la Plage, poster
for Sous la Plage
festival, digital
collage, 2008

Right
Memories of Tomorrow,
digital collage, 2006

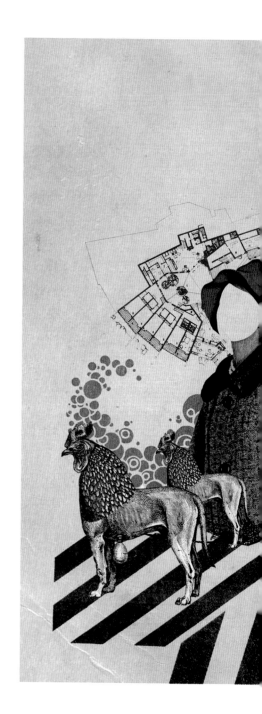

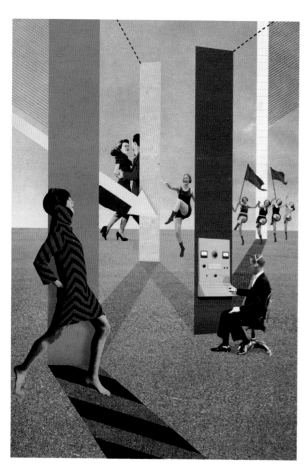

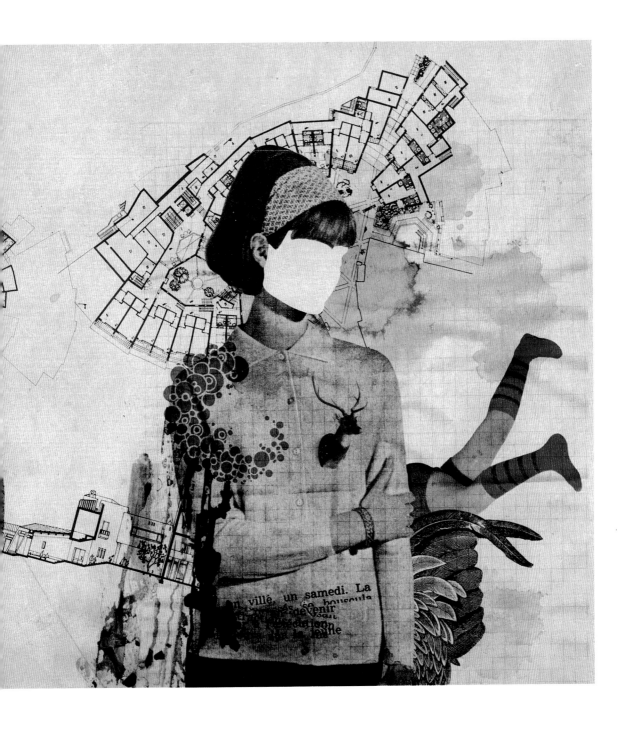

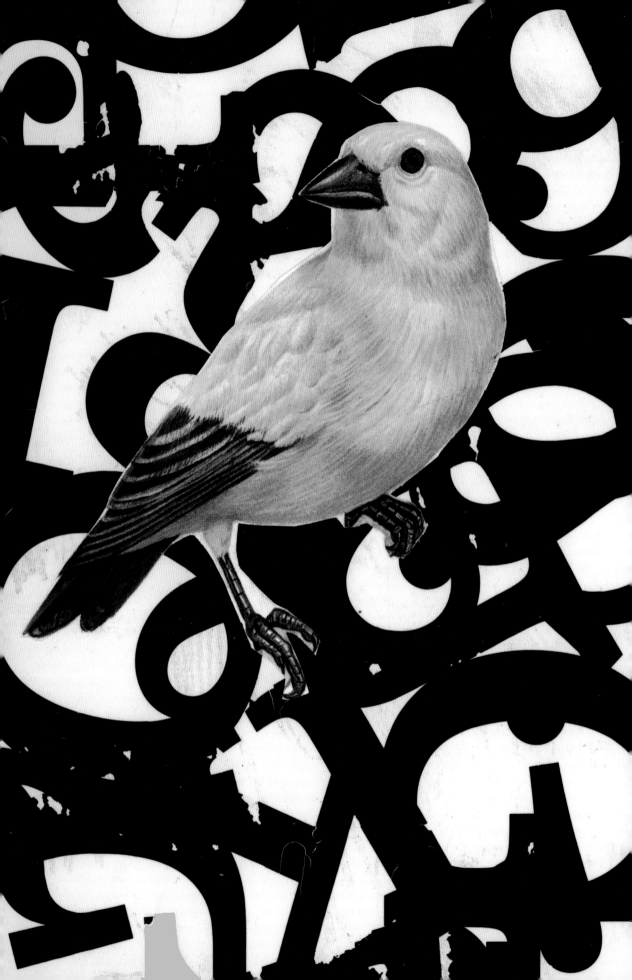

28

ABLE PARRIS

No subject is off limits for North Carolina's Able Parris, although it may not be obvious to the viewer: 'Last year I was looking through the collages I had made and found a theme. Everything was about anxiety and the uncertainty of the future. I made a collage about being lactose intolerant, and I've made some collages illustrating the poetry of creation, grace, motivation and even love, but much of my work is subtle in its messages.' He prefers to use older material due to the cruder quality: 'Most of the material I use dates back to the 1980s or earlier, mostly because the printing wasn't as glossy and true-to-life.' He loves both the restriction and freedom that collage offers: 'I like that collage is a paradox. There are no limitations at all, while at the same time being limited to what you can find, and the hunt never ends.'

Previous page
Perched, collage with
rub-on letters, 2005

Right
Look, collage
on paper, 2010

Below
For Ginny, collage
with rub-on
letters, 2010

Opposite
Fire for Effect, collage
on paper, 2004

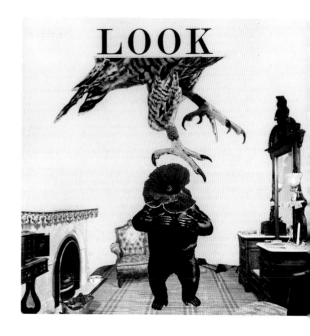

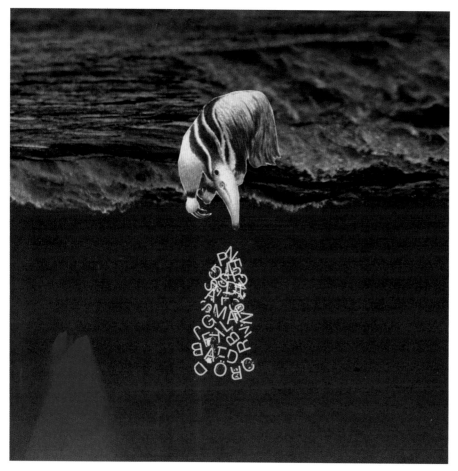

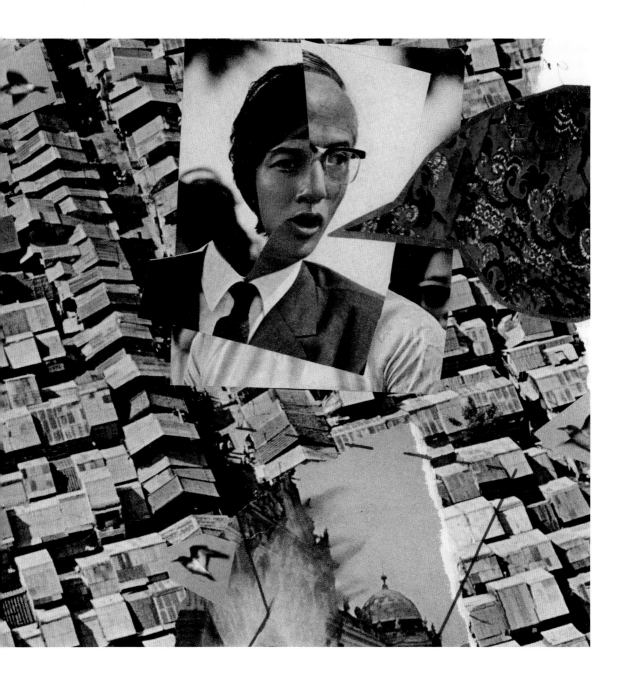

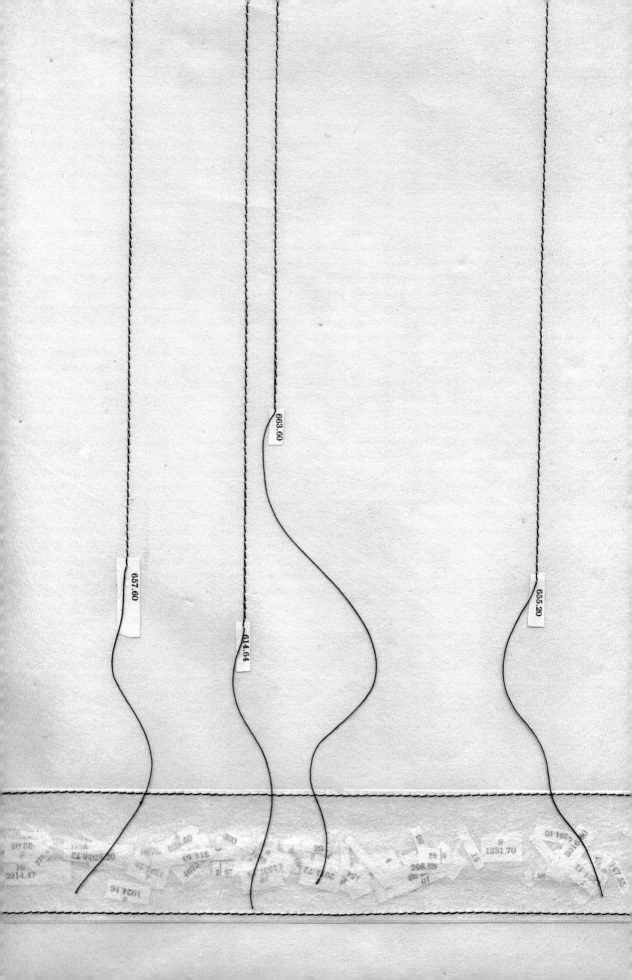

29

TSILLI PINES

Based in Portland, Oregon, Tsilli Pines creates her ethereal collages from found everyday bits and pieces: 'I like the idea of creating something from nothing, so I mostly make use of odds and ends – the detritus of everyday life.' She uses ordinary objects such as erasers as rubber stamps, waste from a hole punch as confetti and waste test sheets to create delicate compositions that often feature stitching and bits of thread. She embraces the experimentation that collage requires and acknowledges the idea of relinquishing control: 'It's an amazing sort of back and forth, where you don't always feel you are the author. It just manifests.' A graphic designer by trade, Pines mainly works on the computer, but her collage art begs an alternative approach: 'The tactile process – the inability to magically undo something once it's been done – is part of why I make art at all.'

Previous page
401K (detail),
pigment, vintage
paper and cotton
thread on rice
paper, 2008

Right
Budgeting, pigment,
vintage paper and
cotton thread on
rice paper, 2008

Below
Fruit of Our Labor
(detail), pigment,
vintage paper and
cotton thread on
rice paper, 2008

Opposite (top)
Annual Report
(detail), pigment,
vintage paper and
cotton thread on
rice paper, 2008

**Opposite
(bottom)**
Leveraged (detail),
pigment, vintage
paper and cotton
thread on rice
paper, 2008

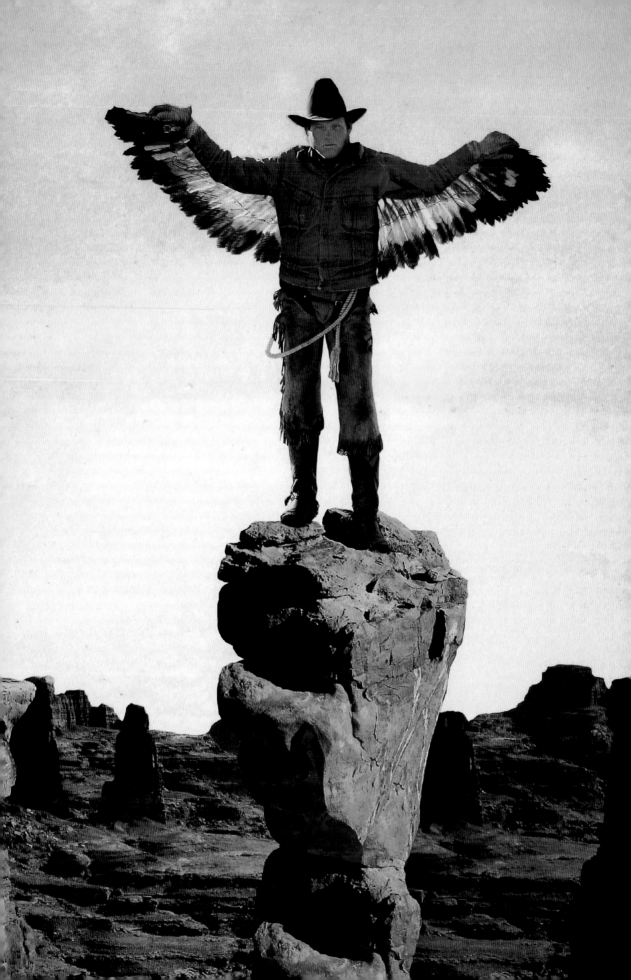

30

JAVIER PIÑÓN

Javier Piñón's sophisticated collages have an almost otherworldly quality, which stems from his passion for mythology: 'I am a huge fan of fantasy and sci-fi. That interest has always influenced the subject matter in my work, from the minotaurs to the medusas.' While the narrative may not have changed, over time his work has become increasingly complicated. He likens making a collage to finishing a jigsaw: 'The puzzle pieces continually move and shift until it just clicks and I know it's right. Sometimes collages will sit unfinished for months or longer because of one missing piece.' Piñón likes the fact that the images can dictate a direction, but rather modestly plays down his part in the creative process: 'I like to think that the best works make themselves, that the relationships between disparate images were always meant to be and I'm just the facilitator.'

Previous page
Icarus, collage, 2009

Right
Medusa, collage, 2009

Below (left)
Icarus, collage, 2009

Below (right)
The Fledglings,
collage, 2009

Opposite
Saint Sebastian, collage
on Amate paper, 2009

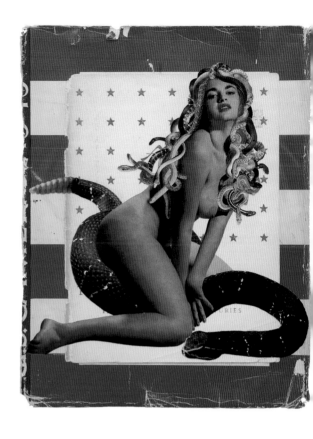

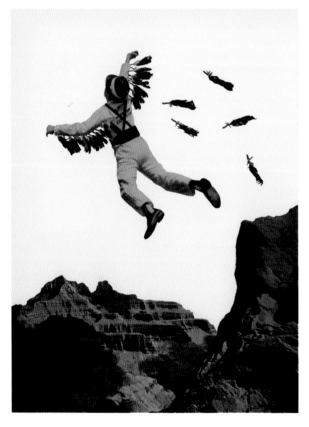

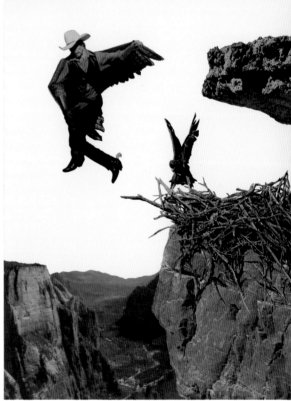

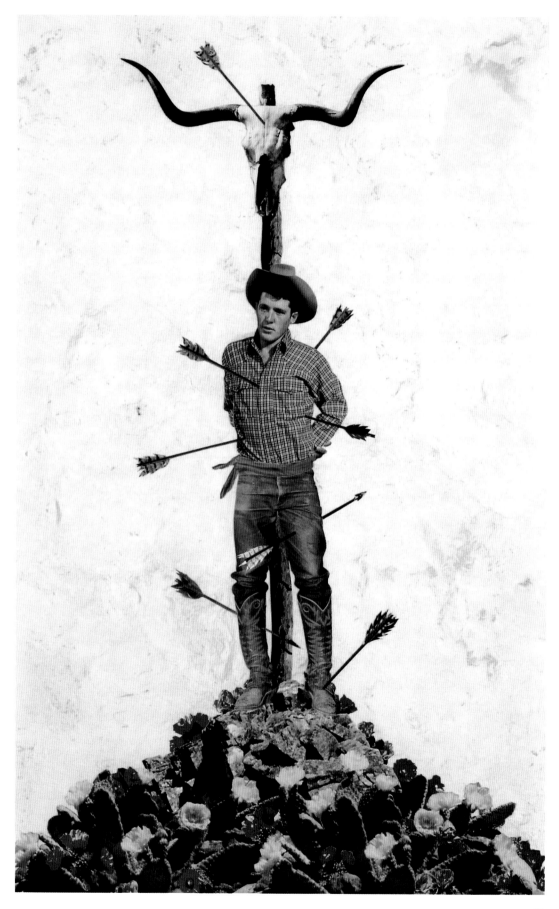

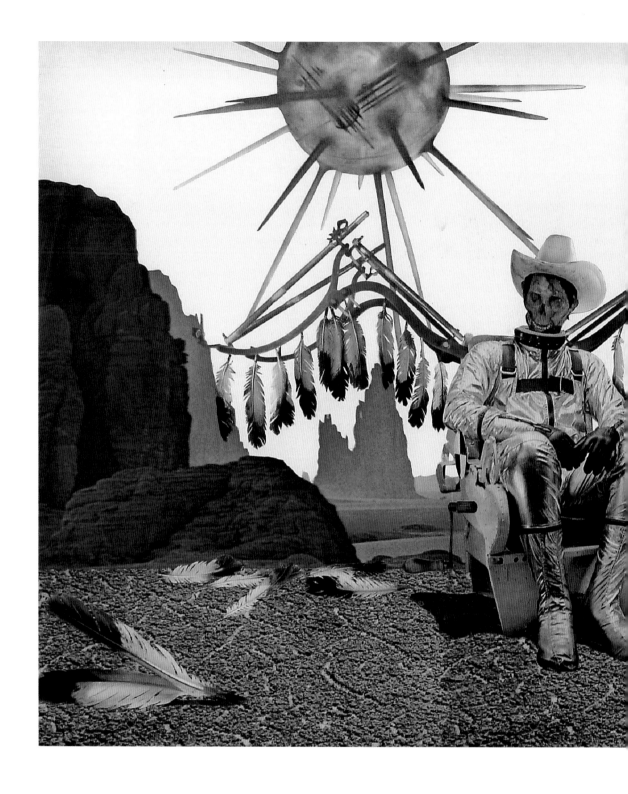

Above
Icarus Rex,
collage, 2009

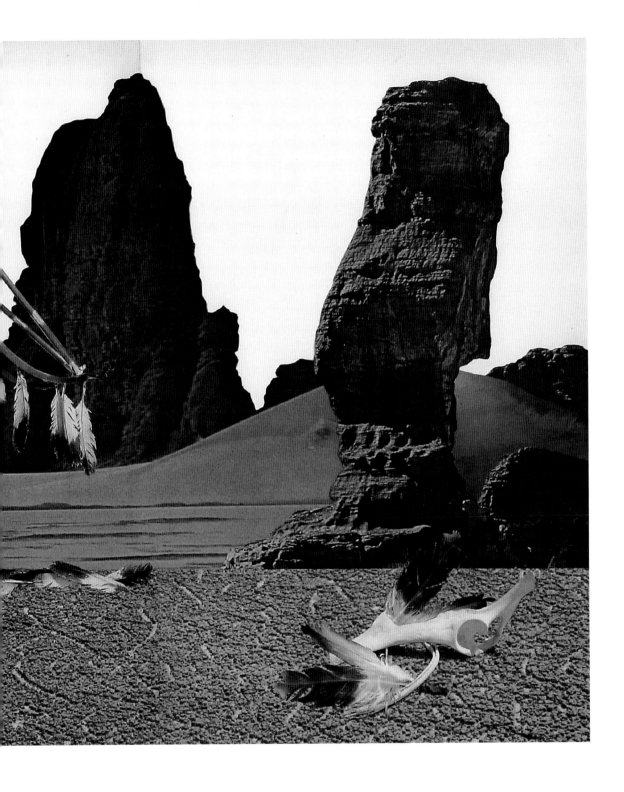

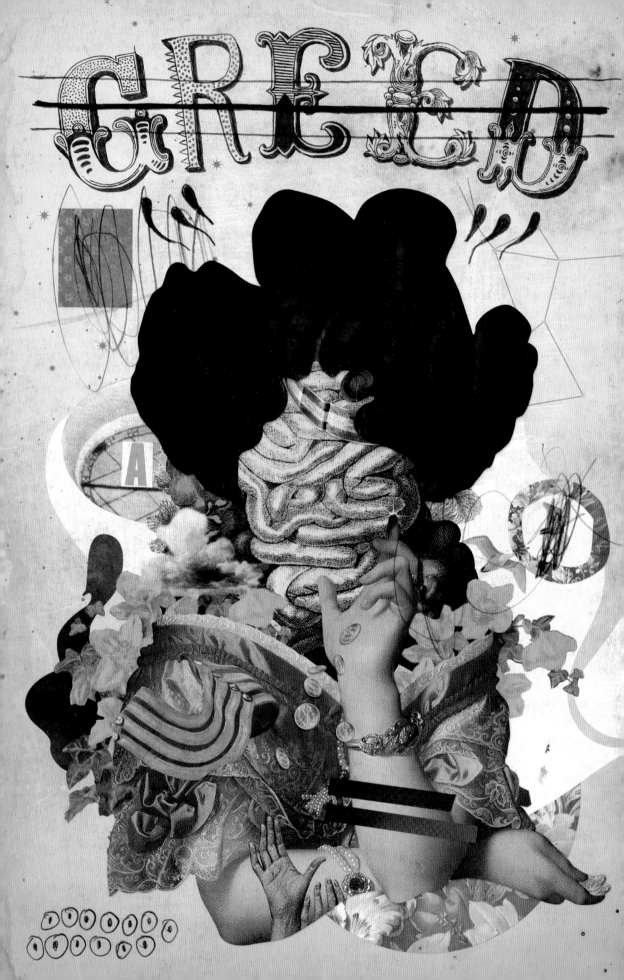

31

EDUARDO RECIFE

Typography plays an important part in Brazil-based Eduardo Recife's work. As well as using it in many of his collaged illustrations, he has created more than 20 typefaces. His collages play with vintage imagery – anything from Michelangelo to Victoriana. They use decorative papers to great effect, creating intriguing narratives: 'I enjoy taking things out of their original context. The process reminds me of how dreams work; where several symbols interact with each other, creating a metaphor or telling a story.' He digitally manipulates some of his images, but never creates the source material himself, as he loves the charm and sophistication of period imagery: 'I'm really obsessed with vintage images, they carry the beauty of time with them. I believe that images were more poetic and expressive years ago, I think it was the effort that was put into them at the time.'

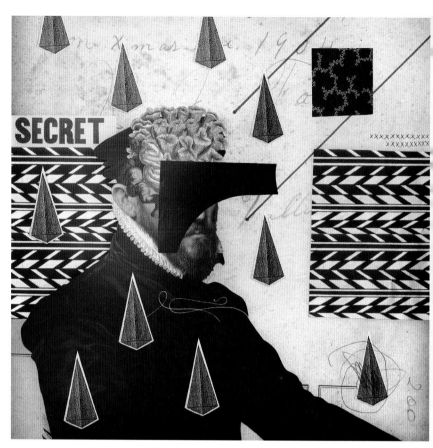

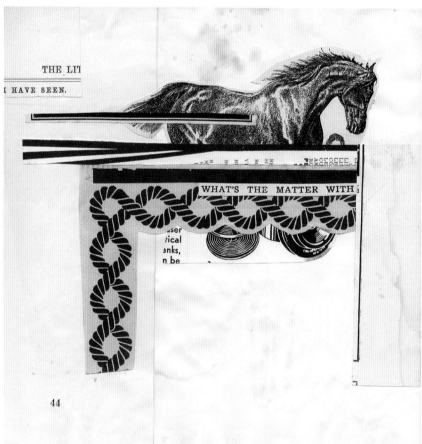

44

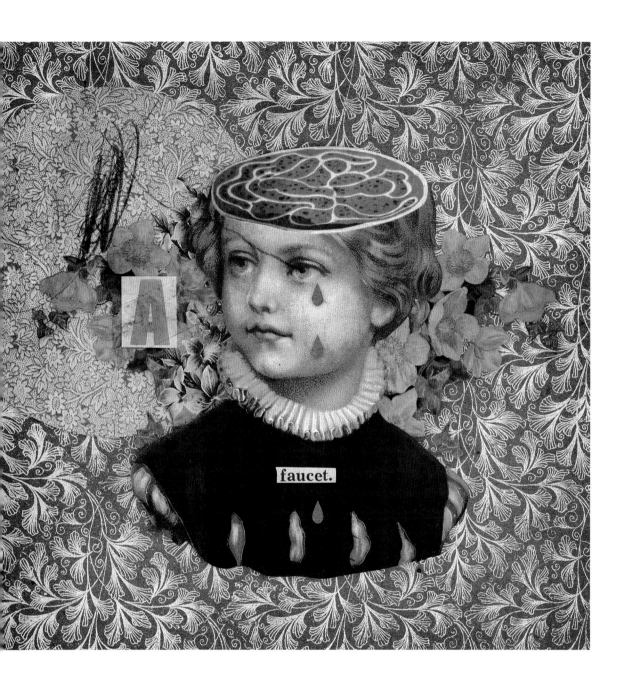

RICO

Tokyo-based designer Rico's delicate work feels like a breath of fresh air. She first discovered the technique of cutting and pasting while working on a college project when she was studying in the Netherlands. Featuring pastel colours and natural motifs such as trees, leaves and flowers, her work uses a mixture of different cut papers and drawing, and is much closer in style to traditional illustration. Her approach is straightforward and playful, which gives it an accessible and sanguine quality. She takes inspiration from her surroundings, so the themes in her work are constantly changing. Sticking a variety of different papers together and working without a pre-arranged plan, Rico lets her collages take shape as she goes along, using memories and drawings to create her fanciful pieces.

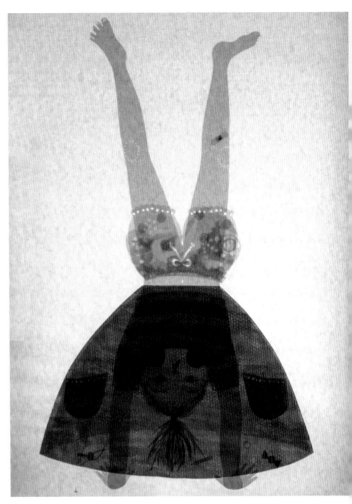

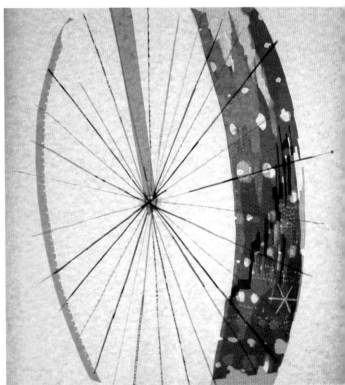

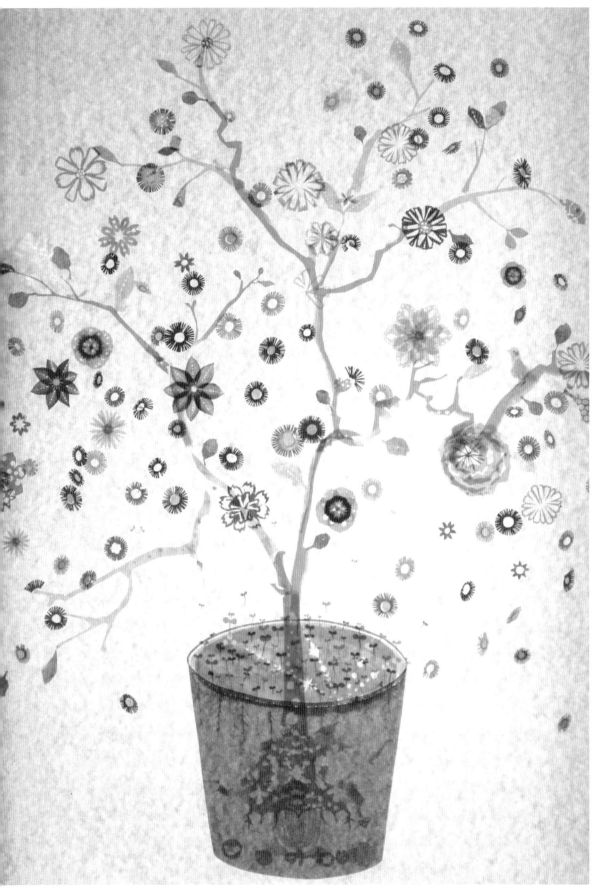

33

ALEX ROSE

Alex Rose's deliberately ambiguous collages feature 'horses, flowers, boys, birds… the magazine boys within the collages are substitutes for people I don't know, people I know that I'll never be able to speak to.' Born in Limerick, Ireland, he began his career at the age of 13 by collecting cast-offs and making shrines for much-loved family pets. His work features found images from newspapers and magazines, and he creates his collages by hand: 'Most of the time I hate the computer and things digital.' When asked how he goes about making his collage work, he explains: 'There is no rational, premeditated thought process. I make something. When it is finished, I sometimes photograph it before laying it to rest. I either bury or burn the work. The photographs are a way for me to unthread a knot. Re-seeing the work.'

Previous page
Untitled, paper collage
on paper, 2009

Right
Untitled, paper collage
and found paper, 2008

Below
Untitled, paper
collage, ink, found
paper, 2008

Opposite (top)
Untitled, paper
collage, graphite,
found paper, 2007

**Opposite
(below left)**
Untitled, erased
magazine paper, 2007

**Opposite
(below right)**
Untitled, paper
collage, graphite,
paper, 2008

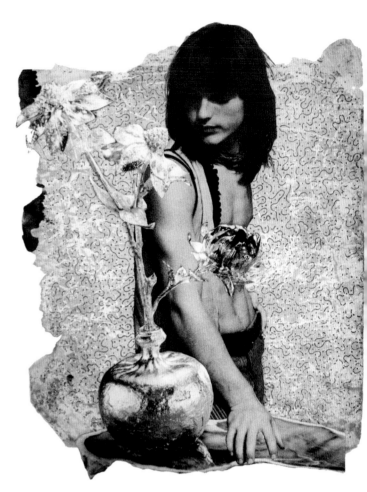

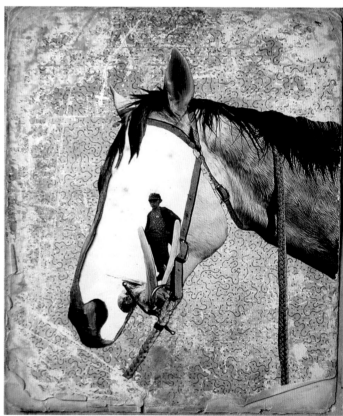

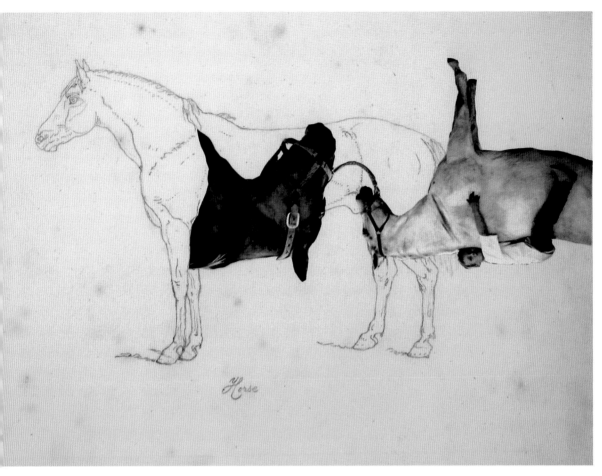

Horse

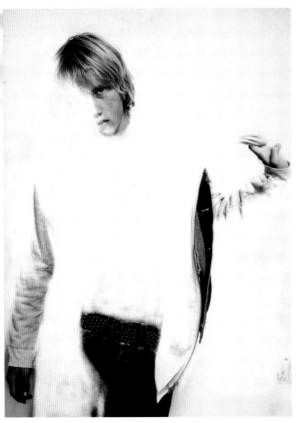

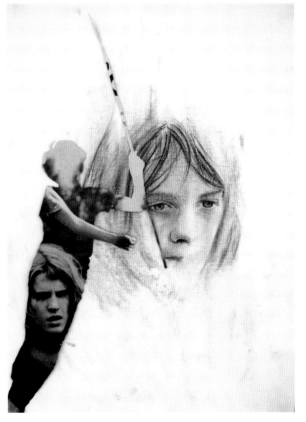

Right
Untitled, paper collage
and paper, 2009

(all images courtesy
of the artist and
Envoy Enterprises,
New York)

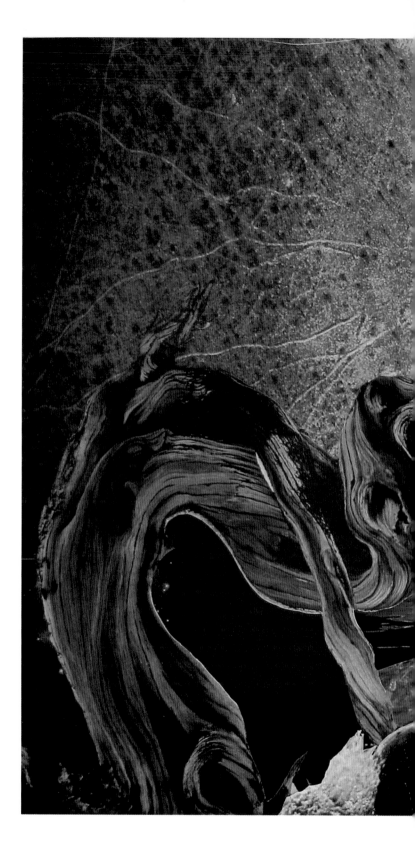

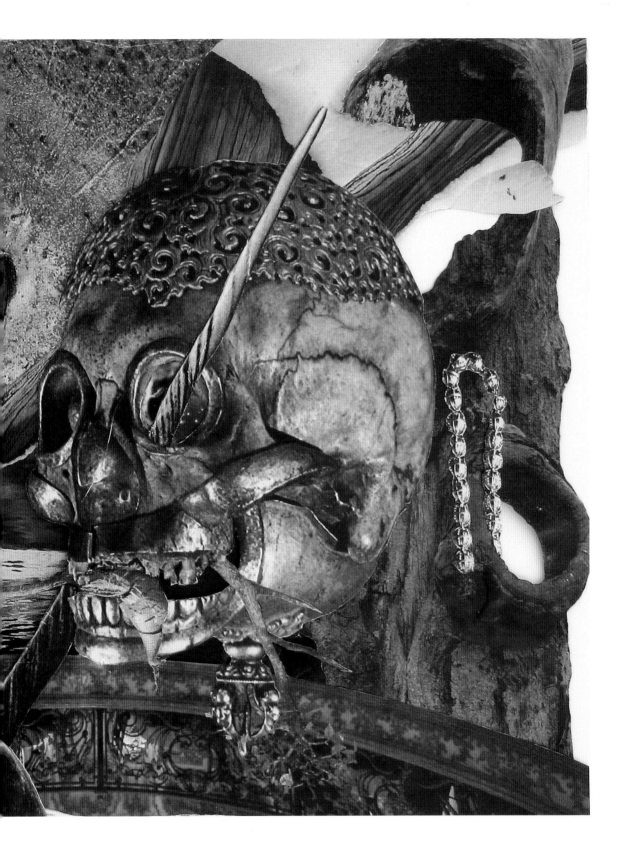

34

VALERIE ROYBAL

Valerie Roybal's work displays a
lightness of touch not present in so
much contemporary collage. Based
in New Mexico, she creates her work
from fragments of discarded books
and magazines, antique postcards,
handwritten letters and recipes, and
charity shop textiles, as well as her own
prints and drawings and mysterious found
objects. Adding ink, paint and pencil on
top of the collaged materials, she often
works on several collages at the same time,
drawing from the same raw materials,
and creating an informal series of pieces.
Roybal is also a printmaker, embroiderer
and book artist. She often frequents her
local library's book sales, where she picks
up discarded and donated books: 'This is
my favourite place for gathering materials.
I'm especially attracted to the books that
are falling apart and/or damaged. I feel
like I can give them a new life by using the
pages making artists' books or collages.'

Previous page
Secret Language 10
(detail), collage on
wood, 2009

Right
6x6 1, collage on
clayboard, 2009

Below
4x4 2, collage on
clayboard, 2009

Opposite (top)
Well-being 1, collage
on wood, 2008

**Opposite
(bottom)**
6x6 3 (Black), collage
on clayboard, 2009

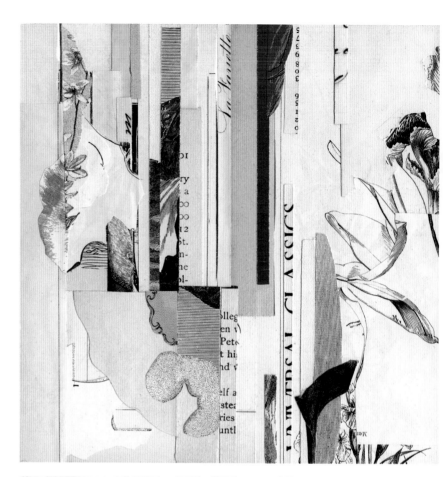

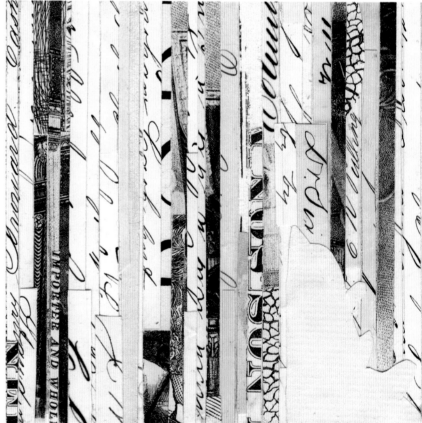

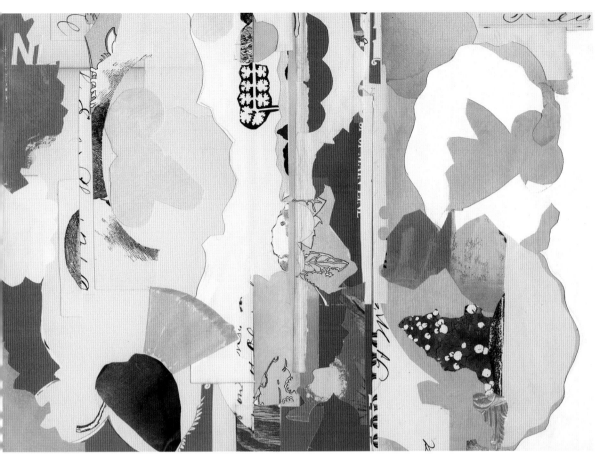

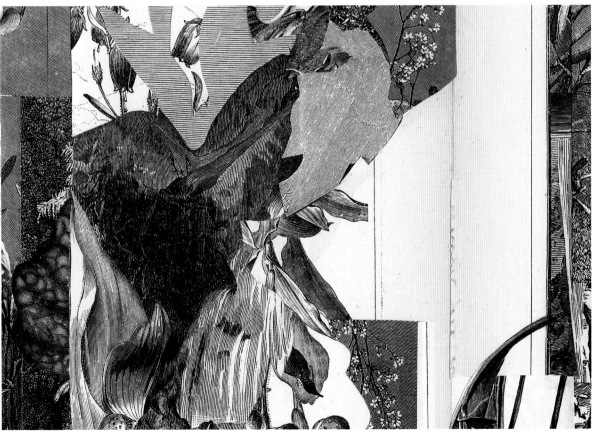

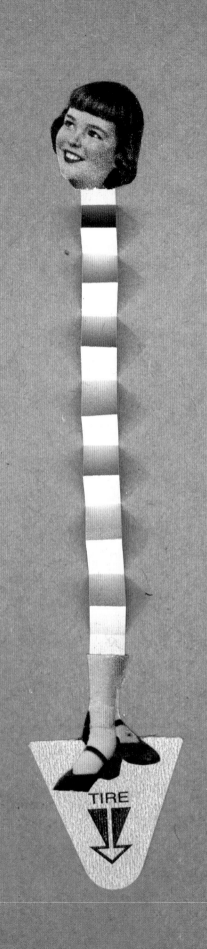

35

DANI SANCHIS

Working from a studio in Valencia, Spain, designer Dani Sanchis enjoys the contrast that creating collages represents. While Sanchis's professional work has always been made digitally, the collage work is created in parallel: 'I have always had the need for an analogue process in which the computer can't feature – touching with my hands, getting dirty, cutting and pasting papers, smelling, creating sketches and notebooks, and using many different tools and techniques.' Taking images from old books and magazines and combining them in intriguing and unexpected ways, Sanchis fully embraces the unpredictability of the creative process of cut and paste: 'Collage gives me the opportunity to travel without knowing the destination, to go to some worlds where it's only possible to get in with paper, scissors and some glue.'

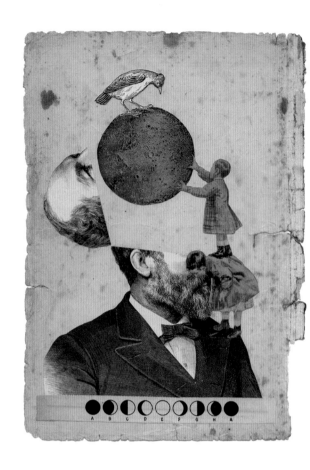

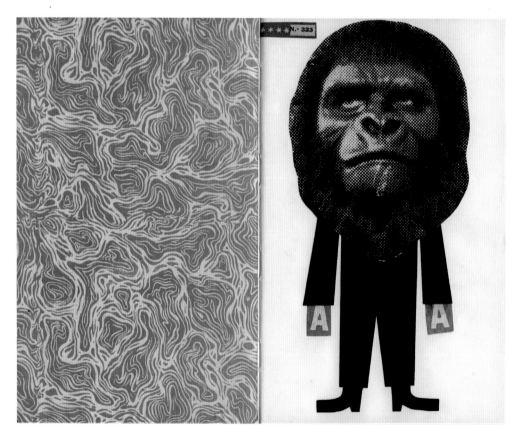

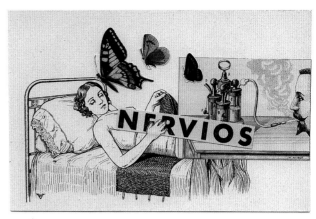

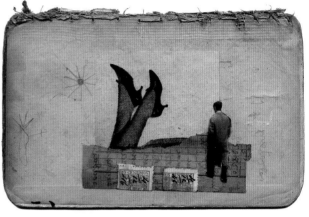

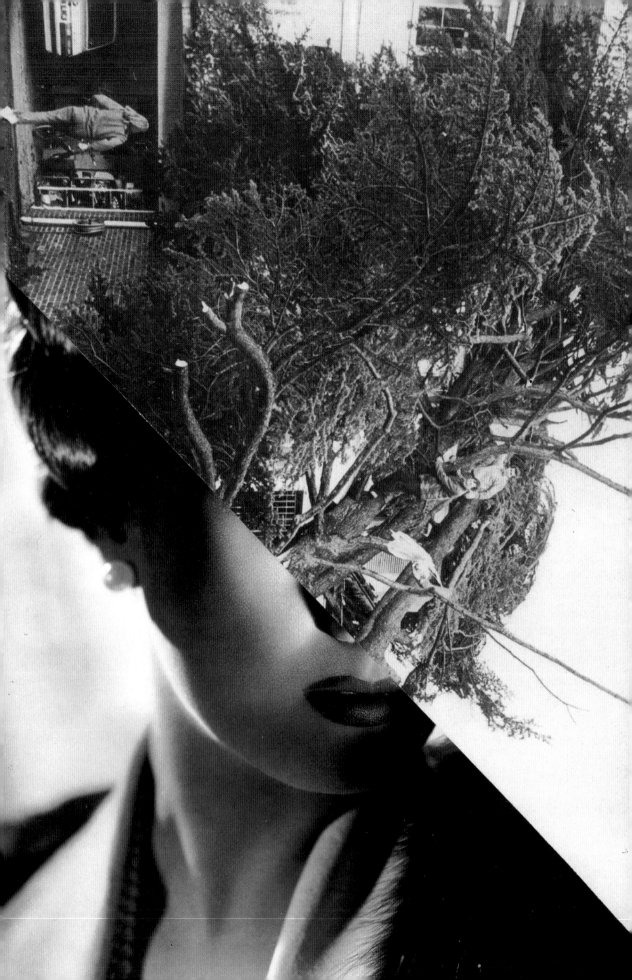

36

✂

JOHN STEZAKER

Artist John Stezaker has collage in his
blood. His personal collection of images
has been amassed over several decades
and includes many cinema-related items
including film stills, film memorabilia
and portraits of movie stars: 'Most of
the image types that I have collected
and used over several decades were all
in my collection by the mid 1970s, so
one might say that the foundations of
the collection were in place from the
beginning, and that I have simply added
to these.' He sees collage as more of a
vocation than a hobby, and has never
been able to work in a studio as he finds
it hard to define where life stops and
collage starts: 'For example, I could just
be browsing through a newspaper and
an image might trigger the search for
something in my collection. Collage is so
tied up with the ordinary consumption
of images, that it is difficult to separate
it from everyday life. I have never really
thought of it as work either.'

Previous page
Film Portrait
(Disaster) *II*,
collage, 2005

Right
Film Portrait (Incision)
VI, collage, 2005

Opposite
Film Portrait (Incision)
V, collage, 2005

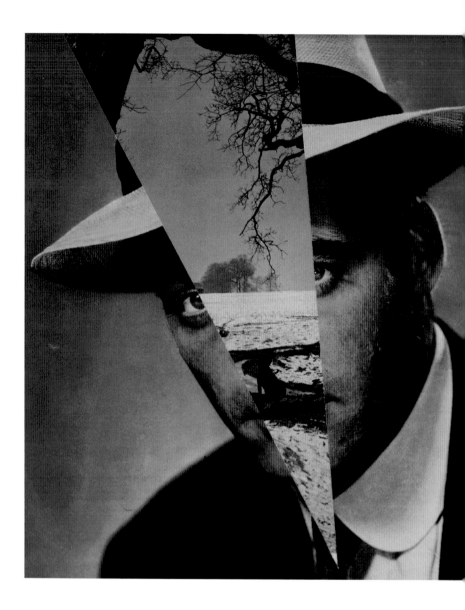

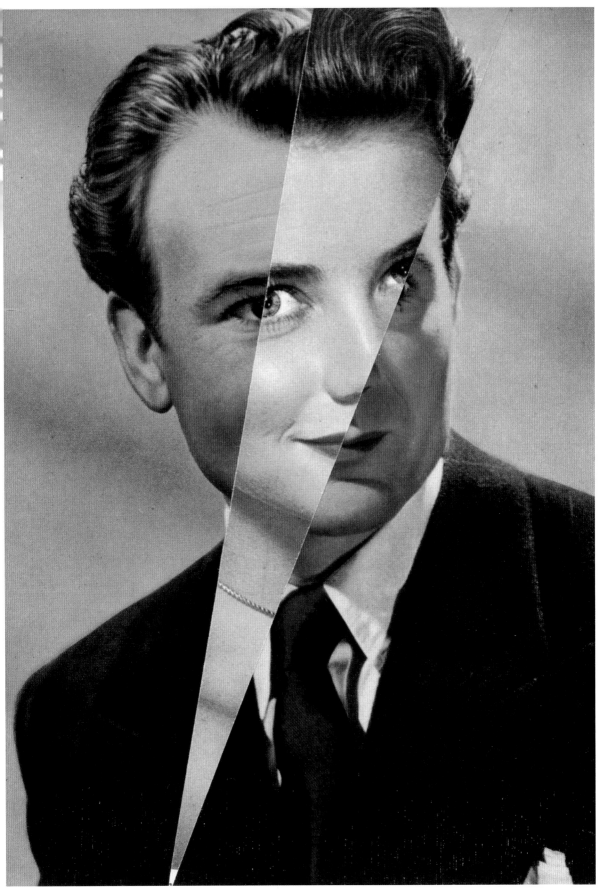

Right
Shadow IV, collage,
2006

**Opposite
(top left)**
Shadow V, collage,
2006

**Opposite
(top right)**
Shadow VIII, collage,
2006

**Opposite
(bottom left)**
Shadow XIV, collage,
2006

**Opposite
(bottom right)**
Shadow XVI, collage,
2006

(all images courtesy
of The Approach,
London)

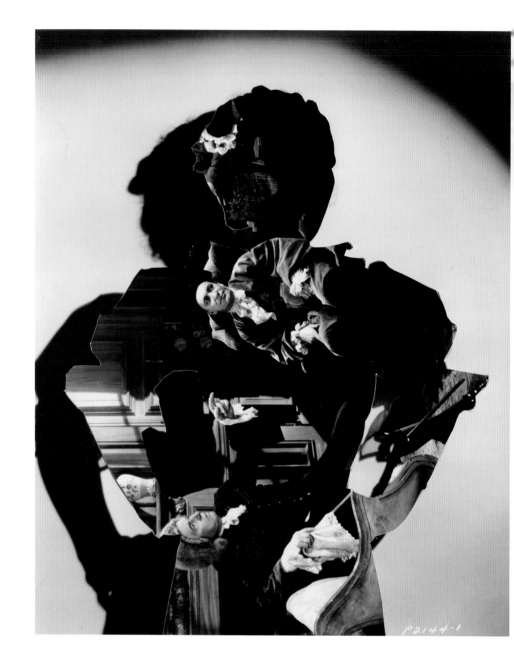

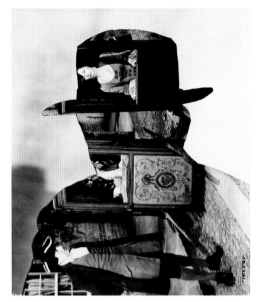
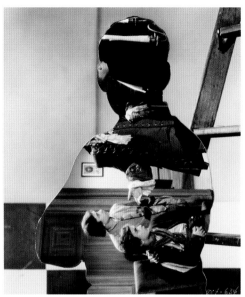
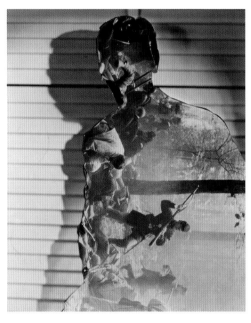
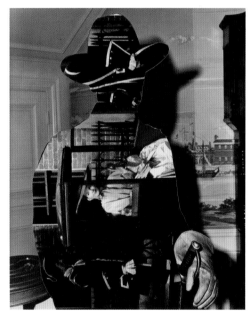

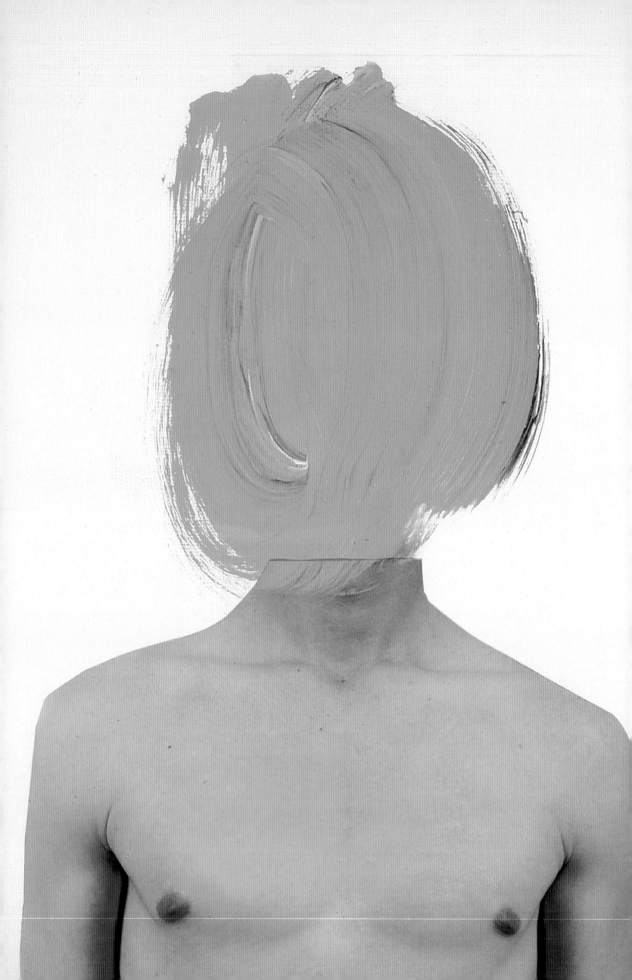

37

SERGEI SVIATCHENKO

Ukranian-born Sergei Sviatchenko is an
artist and architect. Based in Denmark,
he has exhibited in Europe, the USA
and Canada, has received numerous
commissions, and founded Senko Studio
in 2002 – a forum for presenting the work
of emerging artists – as well as an ongoing
art project, 'Close Up and Private', in
2009. His own work is renowned for its
simplicity and directness, an antidote to
the often overcomplicated photomontage
seen elsewhere. Sviatchenko explains
that his works 'explore everyday objects
with the use of photography and collage
elements, which are turned into sharp
contoured, sculptural expressions.' He
aims to show 'the process of navigating
through the rapid flow of visual
impressions that the contemporary
consumer is constantly confronted with.'
Exceptionally stylish, his pared-down
approach and bizarre juxtaposition of
imagery produce an unsettling sensation,
perhaps that of a half-remembered dream.

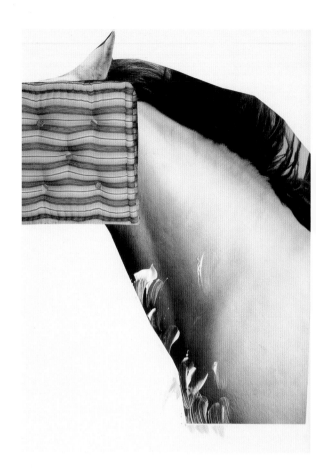

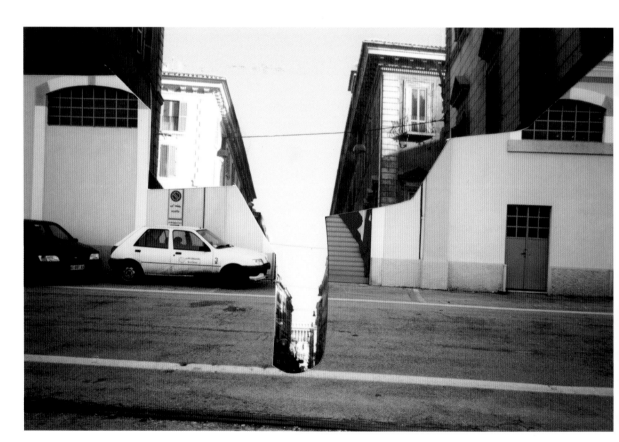

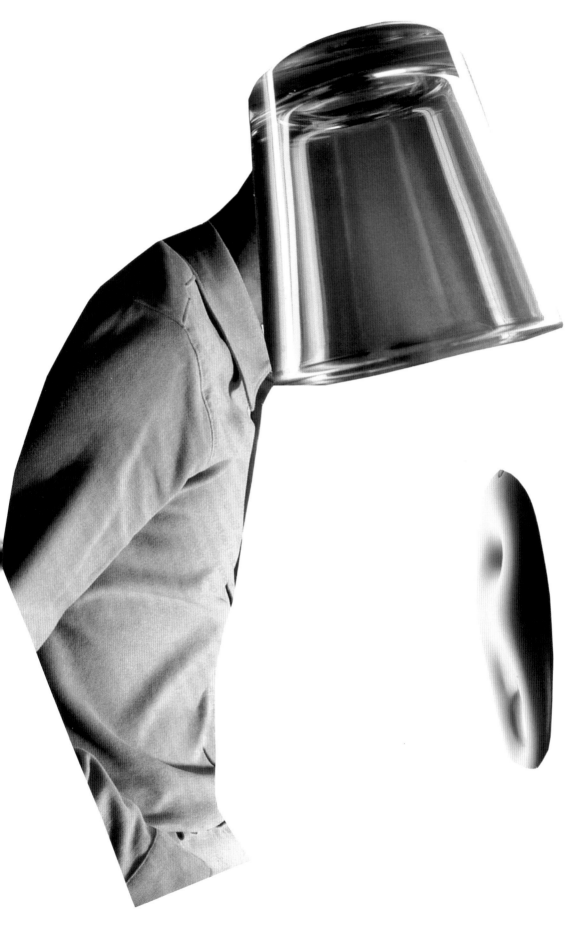

Right
From the 'Gentle
Deconstruction and
Soft Elements' series,
photo collage, 2003

Opposite
From the 'Less'
series, collage
on canvas, 2008

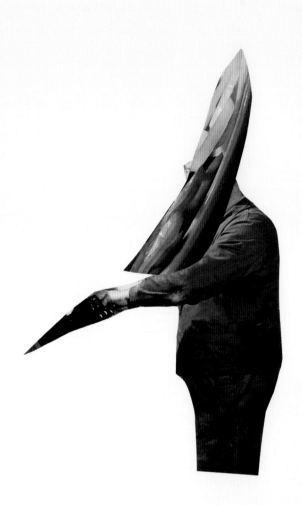

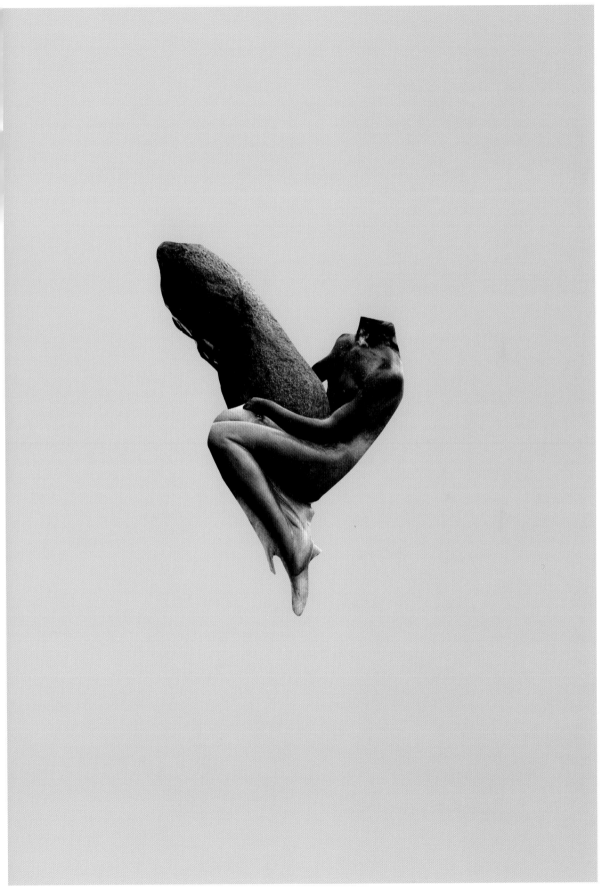

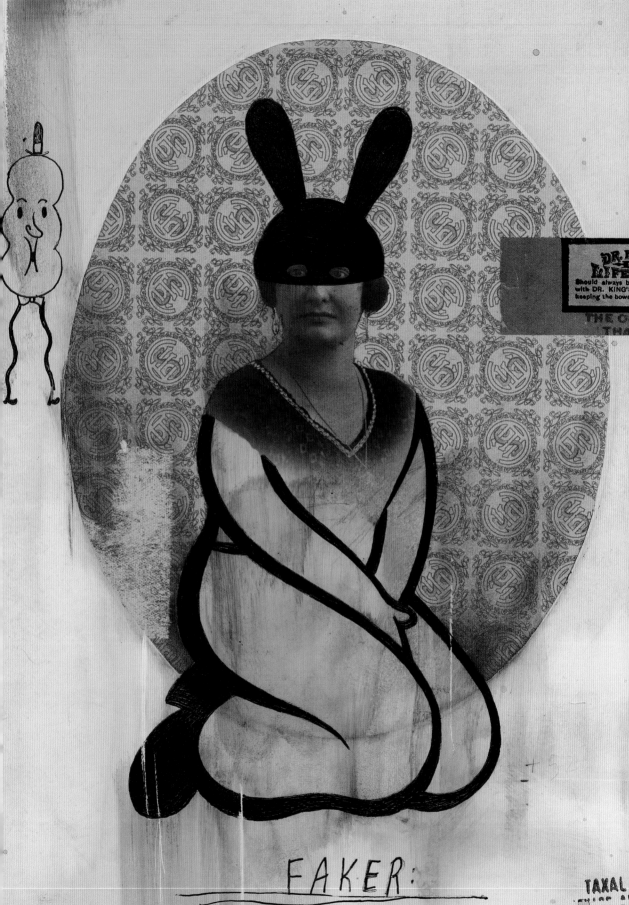

FAKER:

38

GARY TAXALI

Inspired by vintage packaging, Indian-born, Toronto-based illustrator Gary Taxali's playful work always contains type and pictorial elements. These are joined by his hand-drawn doodles and cartoon-like characters: 'The idea of creating something that looks as if it's been defaced or vandalized is something I have always been drawn to,' he explains. He likes the dichotomy that collage offers: 'The surprise factor coupled with a degree of control of placement makes it wholly unique as an art form.' He combines pages from science textbooks with Indian elements and his unique hand-drawn type. The type and drawings are scanned and then screenprinted, half-tones are added and then the whole thing is put together. Taxali admits that he brings a lot of himself to his collages: 'I use a lot of parody and satire in my work. The images have a whimsy and sarcasm which is a reflection of my character.'

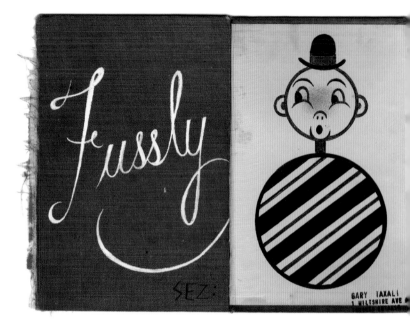

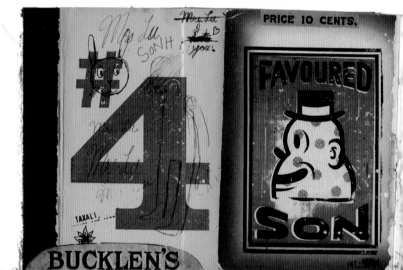

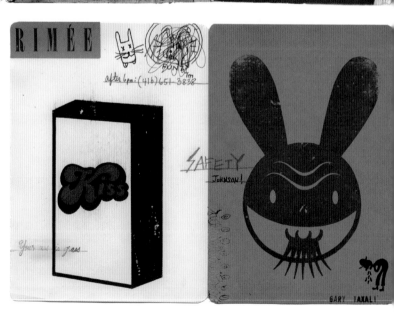

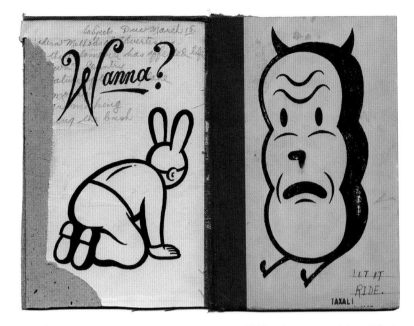

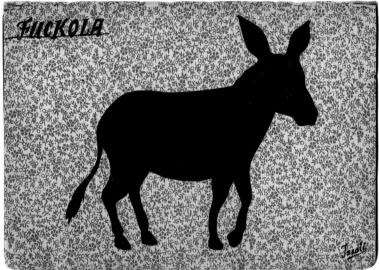

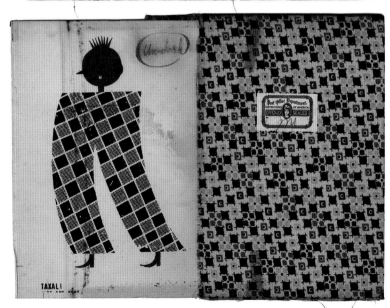

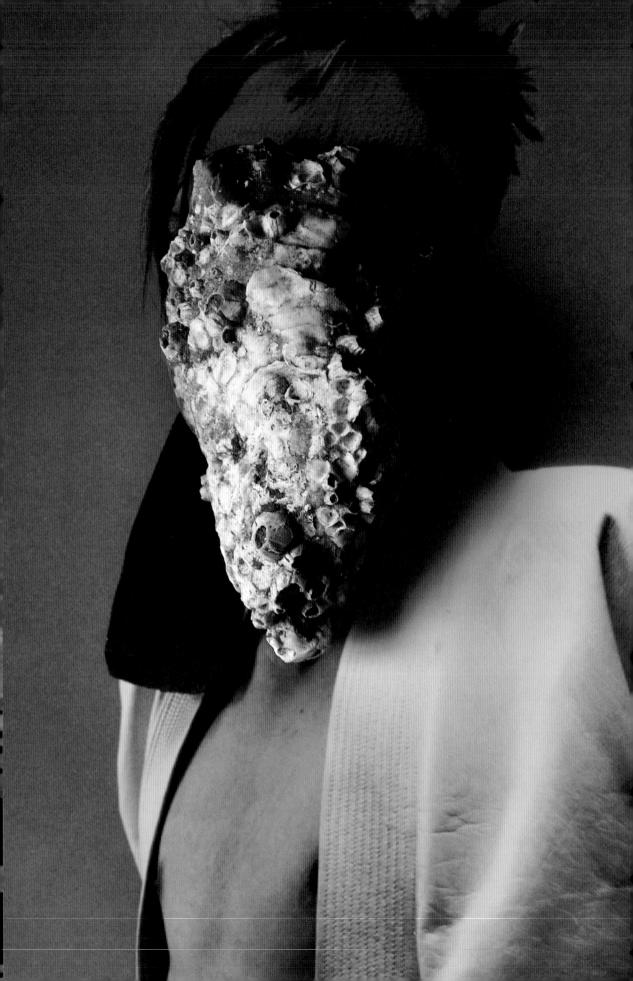

39

IVAN TERESTCHENKO

'I select, cut and paste. It's very basic.'
Photographer Ivan Terestchenko is
based in the South of France, but it was
when he started travelling to far-flung
places that he first discovered his love of
collage. It was impossible to get his film
processed; he would send collages formed
from leaves, fragments of newspapers
and fabric to his friends to share his
experiences. Despite being a self-
confessed 'image eater', Terestchenko
only uses his own photographs in his
elegant, atmospheric collages, and he
loves 'the "No rules" aspect of it. It's
the closest medium to poetry. One plus
one doesn't make two.' He appreciates
that inspired collage is not as effortless
as it often looks: 'For people who cannot
draw, write or photograph, it's a way of
being creative with little skill. Anyone
can do it, all it requires is a personal
approach. This doesn't mean it's easy.'

Previous page
Homage to Albrecht Dürer, colour print and shell, 2009

Right
Dior Staff, argentic print and shell, 2009

Below
L'Esprit Français, argentic print and shell, 2009

Opposite
I Can See You but Can You See Me, colour print and shell, 2009

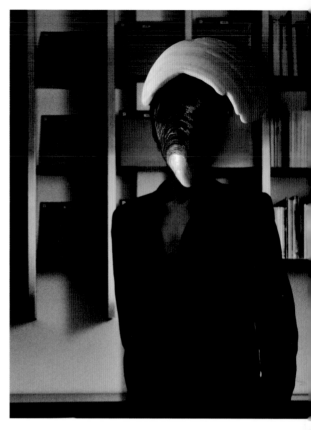

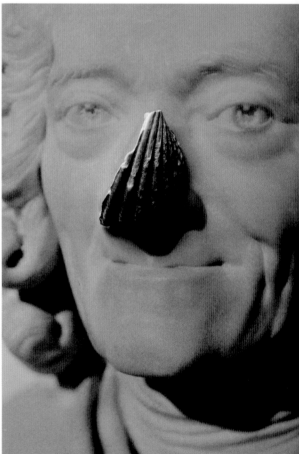

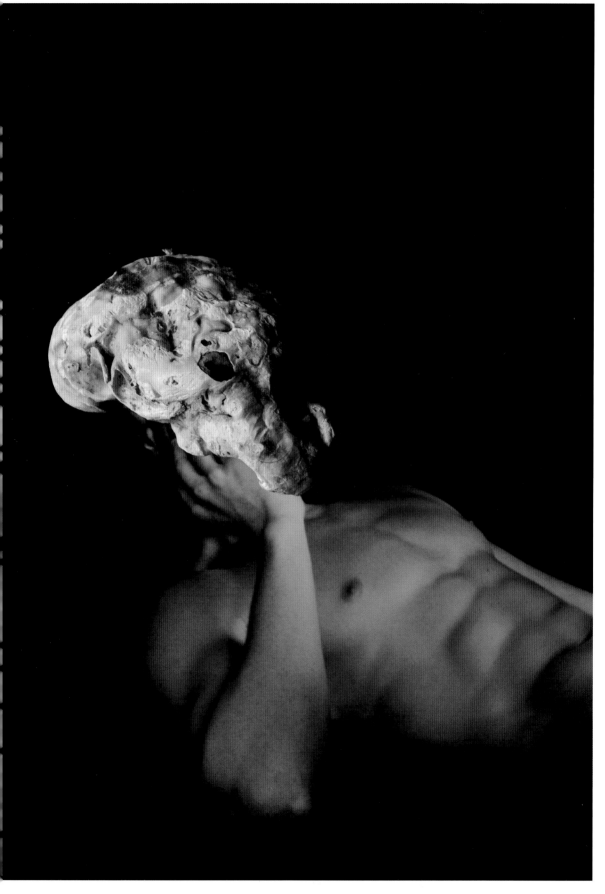

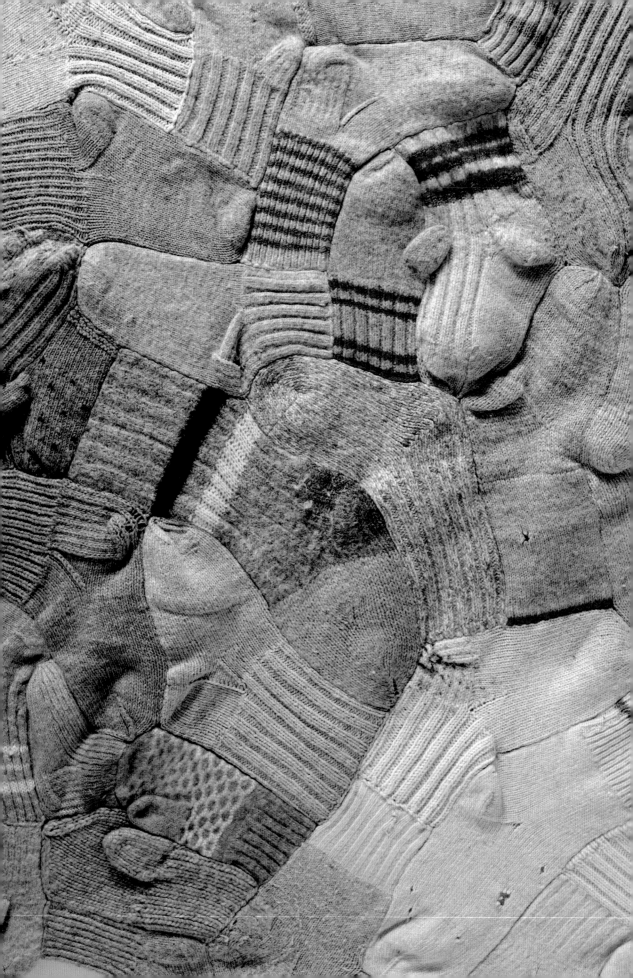

40

ANU TUOMINEN

Daily trips to the flea market have played havoc with Anu Tuominen's living arrangements. Her three studios/storage spaces are now full, and so is her flat. 'I am too lazy to go to my studios,' she jokes, 'I work at home on the sofa watching television at the same time.' The Helsinki-based artist created her first collaged piece after discovering some old maps in the rubbish. It's important to her that she only uses discarded objects in her work: 'I like to use old school books, books that are not rare, not valuable. I don't like cutting, breaking or destroying things.' Paper is just one of the materials that Tuominen works with; she also creates three-dimensional pieces from found objects and textiles, but she always prefers to work with existing materials as 'it is more inspiring, it's ecological and it's cheap too'.

Previous page
Blanket, socks,
mittens, 2001

Below (left)
Scissor the Scissors,
photocopies, cutting,
glueing, 2001

Below (right)
Wintery Lights 1
and *3* ('Postcard
Sculptures' series),
postcards, cutting,
glueing, 2008

Opposite (top)
Wintery Lights 2
('Postcard
Sculptures' series),
postcards, cutting,
glueing, 2008

**Opposite
(bottom)**
*Paavo Nurmi Running
Event* ('Postcard
Sculptures' series),
postcards, cutting,
glueing, 2003

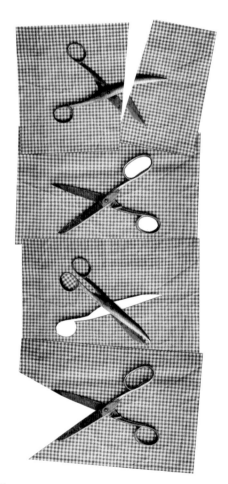

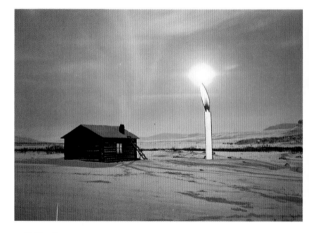

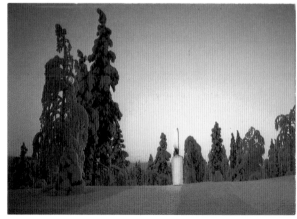

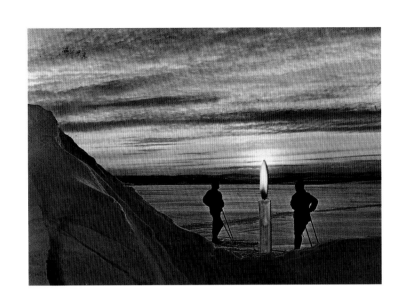

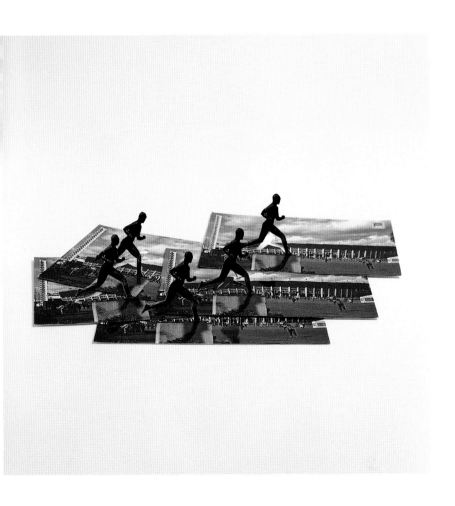

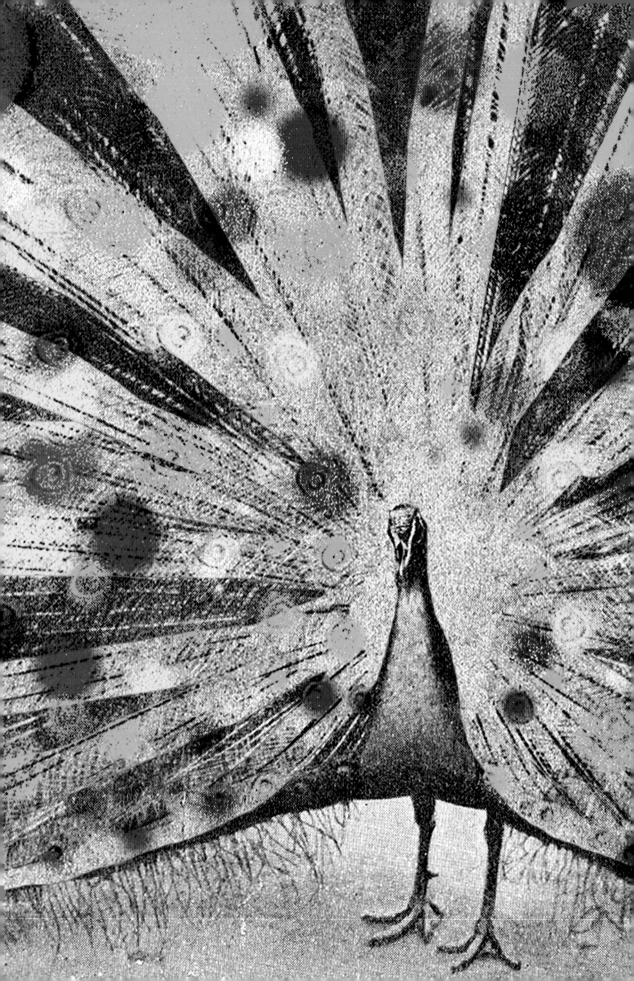

41

WIJNAND VENEBERG

Storytelling plays a big part in Wijnand
Veneberg's collaged pieces. He is inspired
by 'imaginary and atmospheric images,
old prints, black and white illustrations
and woodcuts, magical realism and
surrealism'. His sensitive digitally
created 'Flying Feathers' series looks
at the relationship between humans
and animals, examining themes such as
evolution, extinction, resurrection and
human influence. It uses images from
a book published in 1935 by Ladygina
Kohts, who compared her observations
of an infant chimpanzee with those of
her son. Not one to stick to rigid grids
or systems, Veneberg prefers to 'play
around intuitively – I enjoy getting my
message across using metaphors and
archetypes', embracing the multilayered
sensibility that collage possesses: 'It's
trying to tell you plenty, it's very
layered, literally and figuratively. That's
the power of collage and what's so great
about it.'

All images
'Flying Feathers'
series, digital
collage, 2009

Previous page
#14

Right
#1

Below
#8

**Opposite
(top)**
#5

**Opposite
(bottom)**
#2

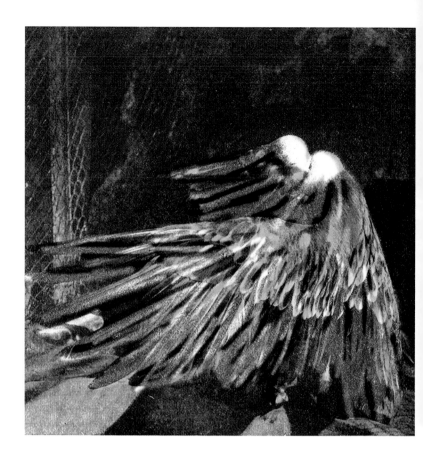

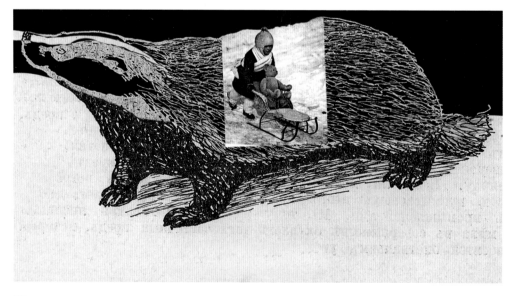

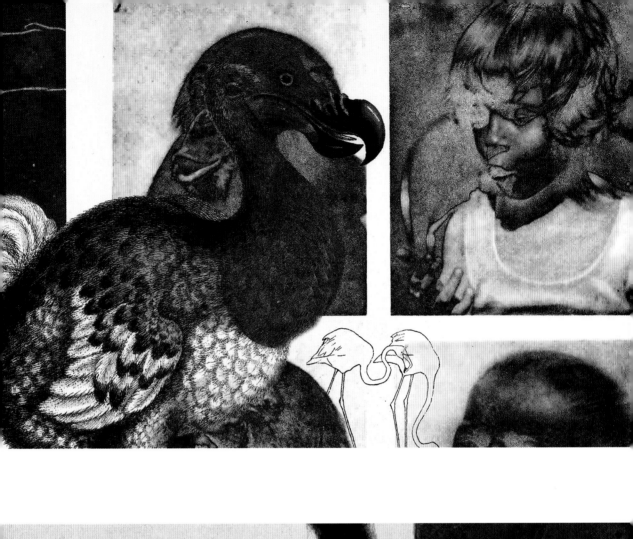
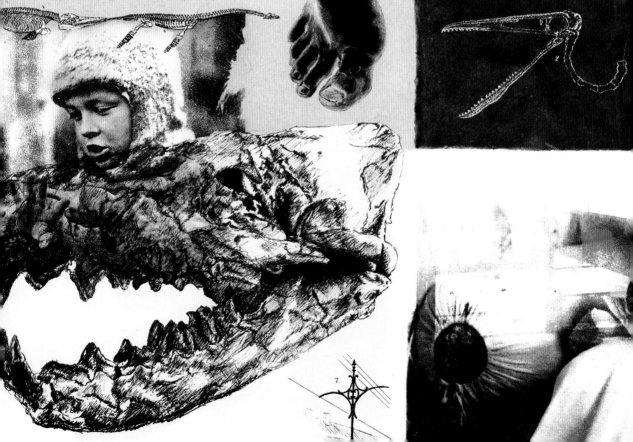

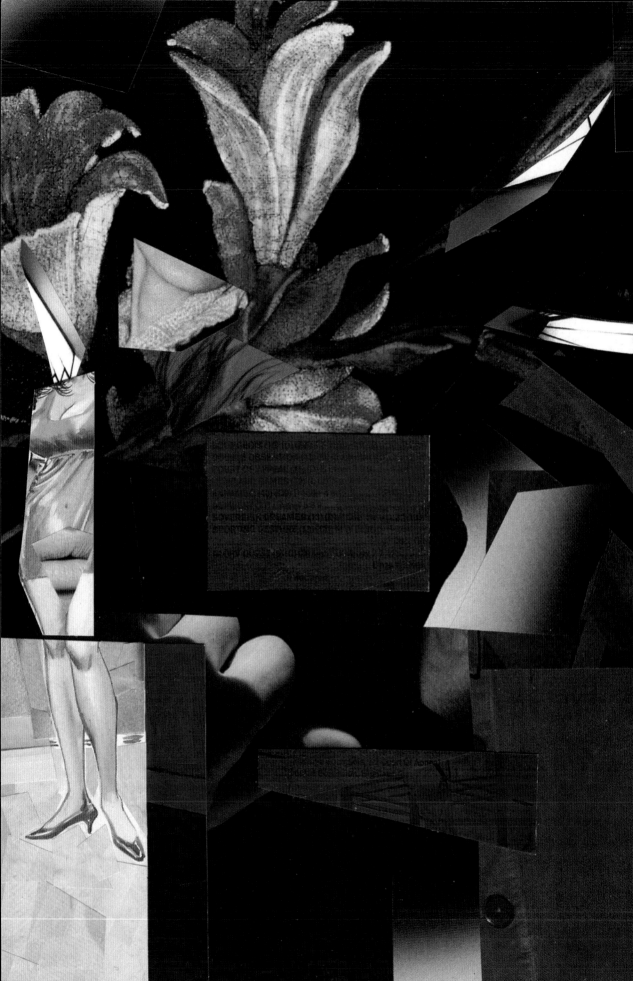

CHRISTOPHER WILSON

Christopher Wilson's background is in graphics, but, unlike design, he finds that 'collage has to be done in solitude'. He makes his sophisticated collages using two distinct methods – the analogue collages are often worked on, left, then returned to later, whereas the digital collages are usually responding to a commission and a deadline. Wilson recognizes that they are two different beasts; altering images digitally removes many restrictions, whereas 'with analogue collage, half of the art is getting around these limitations. In that respect I view analogue collage as more pure.' While he is happy to manipulate imagery in a digital piece, he admits that he is not comfortable digitally tweaking a paper collage. As far as the subject matter goes, he favours a cryptic approach: 'In either mode I dislike blatant "big ideas", just as I dislike them in design.'

Previous page
Tanglehold, collage and
acrylic, 2005

Right
Zealous Host, collage,
acrylic and oil, 2008
(inspired by an
untitled poem by
Frank O'Hara – 'The
eager note on the
door said "Call me"')

Below
*Morgenspaziergang
NE10*, Oberphones
postcard,
photography and
digital collage,
2002/2008

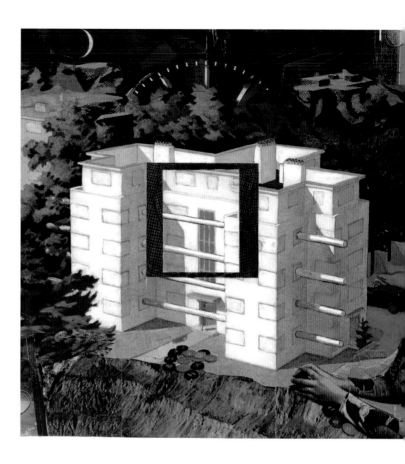

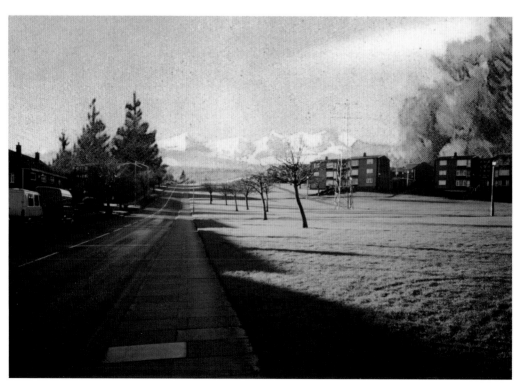

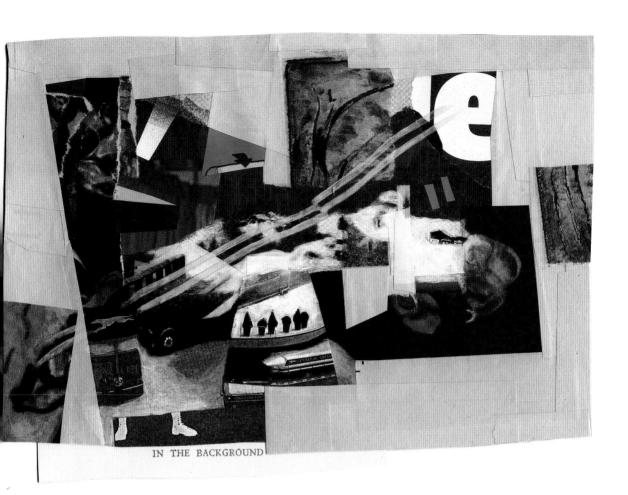

IN THE BACKGROUND

Above
'Alpine' series #1,
collage and acrylic,
2010

Right
Polar Negotiation,
collage, 2008

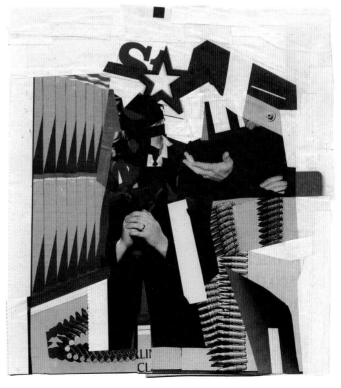

CONTACTS & PICTURE CREDITS

Craig Atkinson
www.craigatkinson.co.uk
www.caferoyalbooks.com
Images courtesy of the artist

Drew Beckmeyer
web.mac.com/drewbeckmeyer
Images courtesy of the artist

Serge Bloch
www.sergebloch.net
Images courtesy of the artist

Bela Borsodi
www.belaborsodi.com
Images courtesy of the artist; first
published V-Magazine #48, US 07

Sam Chamberlain
www.samsara.co.uk
Images courtesy of the artist,
photography by Pedro Gabriel

João Colagem
www.colagem.com
Images courtesy of the artist

Alex Daw
www.alexdaw.com
© Alex James Daw
Images courtesy of the artist.
p44, art direction by Village
Green; p46 (above), design agency
Matchbox Studio; p64 (below),
advertising agency DDB; p47,
advertising agency Publicis

James Dawe
www.jamesdawe.co.uk

Andy Ducett
andyducett.com
© Andy Ducett 2009

Sara Fanelli
www.sarafanelli.com
Images courtesy of the artist;
p54, 56 and 57 © Sara Fanelli
from PINOCCHIO illustrated by
Sara Fanelli, reproduced by kind
permission of Walker Books Ltd,
London SE11 5HJ
www.walkerbooks.co.uk

Eva Eun-Sil Han
evahan.weebly.com
Images courtesy of the artist

Quisqueya Henriquez
Images courtesy of the artist
and David Castillo Gallery
2234 NW 2nd Avenue
Miami, FL 33127
www.davidcastillogallery.com/
quisqueya-henriquez

Markus Hofko
www.rainbowmonkey.de
Images courtesy of the artist; p70
courtesy of Auckland Art Gallery

Ashkan Honarvar
www.ashkanhonarvar.com
Images courtesy of the artist

Julian House
The Intro Partnership LLP
42 St John Street
London EC1M 4DL
www.intro-uk.com
Images courtesy of the artist and
Big Brother Recordings/
Ignition Management

Nathan James
www.ndjames.com
Images courtesy of the artist

Philippe Jusforgues
www.philippejusforgues.com
Images courtesy of the artist

Victor Kaifas
www.Kaifas.co.uk
Images courtesy of the artist.
p94, Sonia Noskowiak
photographed by Martha
Graham (1936); p95, Mae West
photographed by Kenneth Lobben
(1935); photograph by George
Hoyningen-Huene (1931-1938)

Jakob Kolding
Team (gallery, inc.)
83 Grand Street
New York, NY 10013
www.teamgal.com/artists/
jakob_kolding
Images courtesy of the artist and
Team gallery, New York

Kraffhics
www.kraffhics.com
Images courtesy of the artist

Michael Lazarus
michaellazarus.com
p106 and 108 (above) courtesy of
the artist and Brennan & Griffin,
New York; p108 (below) and
109 courtesy of the artist and
Elizabeth Leach Gallery, Portland

Mark Lazenby
www.marklazenby.co.uk
Images courtesy of the artist

Pepe Mar
Images courtesy of the artist
and David Castillo Gallery
2234 NW 2nd Avenue
Miami, FL 33127
www.davidcastillogallery.com/
pepe-mar

Theo Mercier
theomercier.free.fr
Images courtesy of the artist
and Envoy Enterprises
131 Chrystie Street
New York, NY 10002
www.envoyenterprises.com/
artists_pages/mercier.html

Magnus Muhr
muhr.area81.se
Images courtesy of the artist

Christoph Niemann
www.christophniemann.com
Images courtesy of the artist

Julien Pacaud
www.julienpacaud.com
Images courtesy of the artist

Able Parris
ableparris.com
Images courtesy of the artist

Tsilli Pines
www.tsilli.com
Images courtesy of the artist

Javier Piñón
www.javierpinon.com
Images courtesy of the artist
and David Castillo Gallery
2234 NW 2nd Avenue
Miami, FL 33127
www.davidcastillogallery.com/
javier-pinon

Eduardo Recife
www.eduardorecife.com
© Eduardo Recife/
www.misprintedtype.com

Rico
www.rico-m.jp
Images courtesy of the artist

Alex Rose
Images courtesy of the artist
and Envoy Enterprises
131 Chrystie Street
New York, NY 10002
www.envoyenterprises.com/
artists_pages/rose.html

Valerie Roybal
www.valerieroybal.com
Images courtesy of the artist

Dani Sanchis
www.danisanchis.es
Images courtesy of the artist

John Stezaker
Images courtesy of the artist
and The Approach
1st Floor, 47 Approach Road
London E2 9LY
www.theapproach.co.uk/
artists/stezaker

Sergei Sviatchenko
www.sviatchenko.dk
www.closeupandprivate.com
Images courtesy of the artist

Gary Taxali
www.garytaxali.com
Images courtesy of the artist

Ivan Terestchenko
www.itopus.com
Images courtesy of the artist

Anu Tuominen
www.anutuominen.fi
Images courtesy of the artist

Wijnand Veneberg
www.wijnand.net
Images courtesy of the artist

Christopher Wilson
www.oberphones.com
© Oberphones
(Christopher Wilson)